iPhoneography

How to Create Inspiring Photos with Your Smartphone

Michael Clawson

Apress®

iPhoneography: How to Create Inspiring Photos with Your Smartphone

ISBN-13 (pbk): 978-1-4842-1756-6

ISBN-13 (electronic): 978-1-4842-1757-3

Managing Director: Welmoed Spahr
Lead Editor: Jeffrey Pepper
Technical Reviewer: Jim Baggage
Editorial Board: Steve Anglin, Pramila Balen, Louise Corrigan, Jim DeWolf,
 Jonathan Gennick, Robert Hutchinson, Celestin Suresh John, Michelle Lowman,
 James Markham, Susan McDermott, Matthew Moodie, Jeffrey Pepper, Douglas Pundick,
 Ben Renow-Clarke, Gwenan Spearing
Coordinating Editor: Melissa Maldonado
Compositor: SPi Global
Indexer: SPi Global
Artist: SPi Global

Distributed to the book trade worldwide by Springer Science+Business Media New York, 233 Spring Street, 6th Floor, New York, NY 10013. Phone 1-800-SPRINGER, fax (201) 348-4505, e-mail orders-ny@springer-sbm.com, or visit www.springer.com. Apress Media, LLC is a California LLC and the sole member (owner) is Springer Science + Business Media Finance Inc (SSBM Finance Inc). SSBM Finance Inc is a Delaware corporation.

For information on translations, please e-mail rights@apress.com, or visit www.apress.com.

Apress and friends of ED books may be purchased in bulk for academic, corporate, or promotional use. eBook versions and licenses are also available for most titles. For more information, reference our Special Bulk Sales–eBook Licensing web page at www.apress.com/bulk-sales.

Any source code or other supplementary material referenced by the author in this text is available to readers at www.apress.com. For detailed information about how to locate your book's source code, go to www.apress.com/source-code/.

To three people that make my life complete; my wife, Patty, my daughter Tessa, and my son, Nicholas. To my late father and mother who taught me to believe in myself, and always dream.

Contents at a Glance

About the Author .. xi

About the Technical Reviewer .. xiii

Acknowledgments .. xv

Introduction .. xvii

■Part I: The Digital World Reshapes and Disrupts1

■Chapter 1: The Digital Darkroom Is Born 3

■Chapter 2: The Lost Connection 15

■Chapter 3: Touch Takes Hold ... 23

■Part II: Mobile Disrupts The Digital Change33

■Chapter 4: A New Art Form Is Born 35

■Chapter 5: Tools, Tricks and Techniques for Creative
iPhoneography .. 53

■Chapter 6: Seeing Beyond Your Vision............................ 99

■Chapter 7: Connecting With the Community 143

■Part III: Appendix.. 165

■Appendix A: .. 167

Index... 189

Contents

About the Author .. xi

About the Technical Reviewer .. xiii

Acknowledgments ..xv

Introduction ..xvii

■Part I: The Digital World Reshapes and Disrupts.............1

■Chapter 1: The Digital Darkroom Is Born....................................... 3

From Display to Photoshop ... 4

The World Wide Web Opens Doorways 6

The First Digital Cameras ... 7

Enter Kodak Photo CD ... 8

More Digital Cameras Emerge.. 9

Film Hangs In There, Supported by Digital Editing Software 11

■Chapter 2: The Lost Connection... 15

From DSLR to Desktop .. 15

The Limitations of Input Devices ... 17

The Keyboard ... 17

The Mouse.. 18

Other Devices ... 19

The Desktop, a Specialized Creative Space That Confines Us.............. 19

■Chapter 3: Touch Takes Hold ... 23

Enter the iPhone... 25

The App Store Changes Everything 28

A New Workflow is Born... 29

The Connection Between the iPhone and the Artist 31

■Part II: Mobile Disrupts The Digital Change...................33

■Chapter 4: A New Art Form Is Born .. 35

Intimate and Personal, Our Camera is Always with Us........................ 37

Our Experience is Tactile, We Create with Touch 39

An Intimate Workflow ... 42

Touch is Familiar and Natural.. 46

■Chapter 5: Tools, Tricks and Techniques for Creative
iPhoneography .. 53

The Master Shot... 53

Inspiration .. 54

Composition ... 54

Rule of Thirds... 55

Lines, Curves and Shapes .. 56

Balance... 57

Negative Space.. 58

Color ... 59

Light... 60

Depth ... 61

Symmetry and Patterns.. 63

Framing ... 65

Break the Rules and Experiment ... 66

Must Have Apps for Creative iPhoneography and Artistry 67

Shooting Apps .. 67

 Camera (iOS 9) ... 68

 Additional Shooting Modes in Apple Camera App (iOS 9) 72

 CAMERA+ ... 74

 ProCAMERA ... 78

 vividHDR .. 79

EDITING Apps .. 81

 Photos (iOS 9) .. 82

 Snapseed ... 87

 VSCO Cam ... 91

SPECIAL EFFECTS ... 92

 Mextures .. 92

 Fragment – Prismatic effects ... 93

 ALIEN SKY ... 94

Advanced Editing Power .. 95

 Enlight .. 95

Peaceful Coexistence .. 96

■Chapter 6: Seeing Beyond Your Vision ... 99

THOUGHT EXPERIMENTS ... 100

COLOR VISUALIZATION ... 100

 DIRECTIONAL VISUALIZATION .. 104

 INSPIRATION ... 108

 IMAGINATION ... 111

TOUCH EXPERIMENTS ... 112

 TOUCH EXPERIMENT 1: PORTRAIT EDITING ... 112

 TOUCH EXPERIMENT 2: LAYERING ... 119

 TOUCH EXPERIMENT 3: PAINTERLY APPROACH 131

WALKABOUTS ... 137

MISTAKES ARE GIFTS .. 139

Chapter 7: Connecting With the Community 143

Instagram ... 144

Flickr .. 147

Tumblr .. 149

500px .. 150

Facebook ... 151

Twitter .. 154

Behance .. 155

EyeEm .. 157

Pinterest ... 159

iCloud ... 160

Google Photos ... 161

Adobe Lightroom Mobile 162

Where We Are Now 163

Part III: Appendix ..165

Appendix A: .. 167

Shooting Apps ... 168

Editing Apps ... 172

Special Effects Apps 178

Sharing Apps .. 186

Community .. 187

Index .. 189

About the Author

Michael Clawson is 'Chief Fish' at Big Fish Creations, an advertising and digital media company in the Sierra town of Graeagle. His background began in Silicon Valley when Apple Computer and Adobe Systems first made their mark in desktop publishing. He was introduced to interactive media early in his career, transitioned to production artist, and later, creator and lead principal of an interactive department at a major Nevada advertising agency. Specializing in branding across multiple media platforms, his diverse repertoire includes a hybrid combination of designer and developer with emphasis on graphic design, branding, photography and communication. As a speaker, Michael has presented at several industry-specific conferences including Adobe Max and MacWorld.

Michael began communicating as an iPhoneographer in late 2011 when he soon discovered the power wrapped inside his tiny telephone camera. As a professional photographer, he began to explore the limitations of the iPhone (and thus learned its strengths), and soon began to exploit various facets of his creativity with the device. He credits Instagram as the artistic sharing community where iPhoneography and art have flourished, giving him inspiration toward new opportunities and new discoveries. Michael often writes about iPhoneography and creative editing.

About the Technical Reviewer

Jim Babbage, Solutions Consultant, Education, Adobe Systems

Jim Babbage's two passions, teaching and photography, led him to his first career in commercial photography. With the release of Photoshop 2.5, Jim became involved in the world of digital imaging, and he soon began designing for the web in addition to taking photographs. Jim is the author of several books and video training titles on Adobe Fireworks and Adobe Muse, and written hundreds of online articles and tutorials on Fireworks, Dreamweaver, Photoshop, and general web and photography topics.

A former college professor of 21 years, Jim taught imaging, web design, and photography at Centennial College, and web design at Humber College in Toronto, Ontario until he joined Adobe in May of 2011 as a Solutions Consultant for Education. Jim has spoken at a variety of technology conferences, including D2WC and Adobe MAX.

Learn more about Jim's passion for photography at https://www.behance.net/JimBabbage

And

https://www.flickr.com/photos/jim_babbage/

Acknowledgments

I think back to my first mobile phone which I bought around 1996. It was a Motorola. It was the size of a small brick, and had a pull-out walkie-talkie like antenna. It actually felt pretty cool in my hands, and was fun to carry around, but the reception was absolutely terrible, often full of static, distortion, and at times, completely unrecognizable voice transmission. Of course, it had no camera. Some time later I upgraded to a Nokia 6160. This was the first cellphone that I felt was a true mobile phone. It had amazing clarity, and many other features. However, it was not until I purchased a Motorola V551 cellphone that I experience a camera within a phone. It was a basic camera, only VGA quality, but it was the entry point toward my exploration in mobile photography.

A few years later, the iPhone was introduced, which changed my perception of what a mobile phone was really all about. Once I purchased it, I felt like Mr. Spock, holding a tricorder-like device – something much more than just a mobile phone. It inspired me to think and create beyond my boundaries. It was a game changer.

Thus, this book is inspired by my discoveries early on with my first iPhone. It is inspired by the many photography experiments I explored with my family and friends. But more so, it is inspired by so many who have shared my passion to create, and to present my vision of the world, sometimes in ways that maybe I can only understand.

But to really understand oneself means we have to let go of what we fear. In fact, this book would have never been published had I given up after the first publisher closed its division. I owe much to my agent, Carole Jelen, who stuck with me literally through thick and thin to make this new version of my book see the light of day with Apress.

I also owe so much to my family for staying frosty during the transition.

And, to all my friends and family who have supported my mobile photography explorations – from within my heart – I thank you immensely.

Introduction

We are creative beings – each one of us unique. We communicate through sight, through sound, through touch. The world around us is analog, yet in this modern age, we often express who we are in a digital way. In the beginning, that way was basic, limited, and somewhat restraining. The tools kept many of us from achieving true freedom through simplicity, binding us to technical things like the keyboard and mouse. Those of us who mastered an understanding of these tools were able to enter this digital age, and explore creative ideas within the limits of that existing tech. Little did we know that an evolution of touch technology would bring us closer to intimate communication, and ultimately, creative freedom.

For me, my entry into the digital world began in 1987 while working at an Apple reseller store in Los Gatos, California, where I bought my first Macintosh Computer. It was a Mac SE, duel floppy drive, 1 megabyte of RAM, and a 3rd Party 46 megabyte hard drive. As a representative for the store, I received a pretty sweet deal. Yet, it was still a rather expensive investment. I remember thinking to myself, "I'll never need anything more than what I have right now." The power wrapped inside that bulky, portable computer, simply amazed me. I first used the SE in college. Later, I transitioned to music and graphics. In all three areas, the SE excelled, teaching me how easy it was to create using digital technology. Still, there were limits to what I could achieve with the tool. Speed, for example, hampered by the Motorola 68000 CPU, would constantly drag me to a standstill during complex creative projects involving sound and graphic design.

The mouse and keyboard, along with Apple's graphical user interface, though seen as a technical revolution at the time, still limited the way I interacted with the device. I remember having to learn "mouse skills" like moving, dragging, and clicking. These skills that I took as second nature were often a barrier to the non-technical user. Admittedly, I was the self-entitled 'nerd' who could navigate these waters, making sense of how all

this new technology worked. Truth is, I was not alone. The graphical user interface and mouse technology that Apple pioneered shaped the creative industry for years to follow long after its introduction.

Today, touch technology plays a powerful role in shaping the way we use technology. Everything can now be achieved through a tap, swipe, or pinch, or more categorically referred to as "gestures," which are more natural, and easier to grasp.

About This Book

iPhoneography: How to Create Inspiring Photos with Your Smartphone details the essence of what I call the inspiring and intimate touch of creativity through iPhoneography, which is the process of taking and editing photos exclusively with your iPhone or similar device. The technical wall of the computer screen, separated by the mouse and keyboard, is no longer relevant as we move deeper into touch screen technology. From this evolution, the mind is free to connect faster in much the same way as a painter connects with the canvas, or a musician connects with the instrument.

THIS BOOK WAS WRITTEN for the curious photographer who is looking for inspiration, and new ways of expressing their vision with iPhoneography. It's for the artist in us all, exploring new pathways and connections into mobile art. *iPhoneography: How to Create Inspiring Photos with Your Smartphone* is a perfect source for creativity and insight into the growing iPhoneography and mobile art movement. Readers will gain an understanding of the methods used in photography and iPhoneography, including the connection between the iPhone and the artist, as well as practical tips and techniques for creating and sharing photos and art with an iPhone or similar device.

The Digital World Reshapes and Disrupts

Creativity is just connecting things. When you ask creative people how they did something, they feel a little guilty because they didn't really do it, they just saw something. It seemed obvious to them after a while. That's because they were able to connect experiences they've had and synthesize new things.

—Steve Jobs

The computer revolutionized desktop publishing and creativity. Here, I'll present a brief overview of how tools like Photoshop evolved, and how digital photography, once seen as limited, soon gained ground in many creative industries.

Part I will discuss the transformation from DSLR cameras and desktop editing to the iPhone and iPhoneography.

You don't take a photograph, you make it.

- Ansel Adams

The Digital Darkroom Is Born

Early Software and Hardware That Started The Digital Photography Revolution

I never experienced the original darkroom. That darkroom made of chemicals, papers, processing tanks, safe lights, enlargers, and the like. The first darkroom I experienced was digital, right inside my computer. In fact, it was a program actually named Digital Darkroom, which was created in 1987 by Silicon Beach Software. What made Digital Darkroom so special was its ability to edit gray-scale images, something Apple's MacPaint couldn't do at the time. Though Digital Darkroom was limited to black and white images, it set the stage for the transition from the "analog" darkroom into digital.

I remember playing with Digital Darkroom at the computer store where I worked during college in the late 1980s. (Figure 1-1) We had it set up on a Mac II with 4 MB of RAM, a 40 MB hard drive, an Apple 13 inch color monitor, and Apple Scanner. The equipment sprawled across an entire desktop, literally. A set up like this was not cheap; easily up to $10,000. Far more expensive than a traditional darkroom at that time, and not as versatile when compared to its limited features for photo development, processing and editing. Yet, this was the new direction photography would evolve from in the years to follow.

Figure 1-1. Dialog Box for Digital Darkroom. Source: MacTech

At that time, the process was simple: place a photo on the scanner and import it into the computer via scanning software. You would typically start with a preview scan in order to get a sense of your final result before you tweaked the settings and adjustments prior to the final import. And, you could only work with gray scale images, since the first scanners didn't support color scanning. On Macs that didn't support a higher gray scale or color display depth, the image was dithered in black and white (1-bit) on the display. You could still work with the image and make some adjustments, but it was difficult to get a true sense of what you had done to your image until you printed it out on something like an Apple LaserWriter PostScript printer.

From Display to Photoshop

Around the same time that Silicon Beach Software introduced Digital Darkroom, other companies like SuperMac, offered competing image processing apps. Also at that time, two brothers, Thomas and John Knoll, (Figure 1-2) whose father had taught them traditional dark room techniques in his basement darkroom, began exploring a program they first called Display.

Figure 1-2. *John and Thomas Knoll. Source: Resource Magazine Online*

It turns out that Thomas Knoll, who was studying image processing for his Ph.D. at the University of Michigan in the late 80s, was frustrated at the lack of display depth in the early 1-bit Macintosh computers, and therefore created a custom program on his Mac Plus to deal with this deficiency. Thomas' brother, John, who worked at Industrial Light and Magic (ILM), soon discovered that his brother's program shared similarities to the custom programs he used on the job. With this common bond, the brothers set out to develop a new program that they named, Display. John later purchased a Mac II workstation, which opened the doorway to the development of advanced imaging features like gamma correction, file format conversions, and tone adjustments (i.e. levels) just to name a few. It was not long before the two realized they actually had something in terms of a viable image-editing program, which set them on a course to sell their invention to a willing buyer.

As the program developed, the brother's changed the program's name to Image Pro, and began the hunt for investors. They approached many investors, including Adobe, who at the time, had no real interest in it. As a result, and after renaming the program again several times, they eventually found limited success with a company called BarneyScan, who bundled the software, now named Photoshop, with their BarneyScan XP. After their limited success with BarneyScan, Thomas and John approached Adobe again. They were fortunate enough to pique the interest of Russell Brown, Adobe's art director at the time, who immediately fell in love with the program, and pushed it forward for the company to acquire.

The World Wide Web Opens Doorways

In 1993, after I graduated college with a degree in Creative Arts, I moved north to the Reno area, where I sold computers for a Mom and Pop store. I spent my downtime on the showroom floor running through the tutorial exercises for Photoshop 3.0, to better understand how the program worked, and how to integrate it within my workflow. Every new technique I learned in Photoshop opened my eyes to the creative potential of the program. One area I paid particular attention to was file formats. I was familiar with the different types such as JPEG and GIF since I had been using those formats with a program called Director, which was made by Macromedia.

One day, my boss invited me to look at something on the computer screen. It literally felt like I was at a circus sideshow, and he was the shill, complete with the 'hey kid, come here, take a look at this" grin. But, what he showed me that day was nothing to laugh about. It was the World Wide Web. It blew me away. Though I was familiar with online providers like AOL and Prodigy, the Web was different because I immediately understood its unlimited potential, its connectivity, and the technology under its hood, i.e., Hypertext Markup Language, better known as HTML. I trained myself to write the code and began to build mock web pages. With this new skill, I soon outgrew my present career and knew I had to venture to greener pastures.

My career path pointed me in the direction of advertising. My wife was the catalyst since she was currently enrolled at the University of Nevada, Reno in the college of journalism. She recommended I try for a job at a local ad agency. I was eager to give it a try, but lacked a proper advertising portfolio. So, I devised a clever solution–I created an interactive resume that I delivered on a floppy disc. It was a cutting edge approach that got me hired on the spot as a production artist, and presentation specialist, that is, the artist in charge of building the computer generated presentations the agency used to pitch clients like MGM Grand and Silver Legacy. This new career placed me in the driver's seat of digital creation, where I soon began to hone my skills as a digital artist. Later, I lead the Internet Web Division for the agency, building small websites for their clients, thus furthering my skillset.

The reality of my new career didn't hit me square in the head at first. Though I was humbled to be part of such a large agency, I was really at the tail end of the "traditional agency approach." That approach involved old media like radio and print, and still relied heavily on darkroom film photography. In fact, I was amazed at the photographer who was employed by the agency; he was truly a genius, and understood the old-school method of the darkroom. In hindsight, it might have been fun to take some time, and learn the process from him. But I was a digital guy, and was driven by technology. To me, the writing was on the wall, and I believed it was only a matter of time before the technology could catch up with the industry. Of course, it didn't happen overnight.

The First Digital Cameras

Kodak is credited for creating the first digital camera prototype in 1975. The prototype, conceived by Kodak engineer, Steve Sasson, (Figure 1-3) weighed 8 pounds, and used a 100 x 100 Fairchild Semiconductor sensor to effectively record a black and white image in a resolution of 0.01 megapixel to a cassette tape. A dimension so small by today's standards! But, Sasson's bulky invention never saw the light of day, effectively being shelved by Kodak's top brass. Who could blame Kodak for their lack of foresight? As a leader in analog film technologies, Kodak viewed Sasson's invention as rather primitive at best, and continued to focus their resources toward analog technology.

Figure 1-3. Steve Sasson with his 1975 Digital Camera Prototype.
Source: British Photographic History

It took over a decade before Fuji first introduced their digital camera prototype called the Fujix DS-1P, which was introduced as the world's first consumer digital camera. Like Sasson's concept, the DS-1P never went into production. Conceived as a joint project by Fuji and Toshiba, the DS-1P had one clever feature–a removable Toshiba SRAM card. Again, the innovation was alive, but the market wasn't ready for the transition.

In 1991, Dycam made a bold step into consumer digital photography with their Dycam Model 1 digital camera. It was very limited in its overall technology, featuring only 8-bit, 256 colors capturing at 376 x 240 pixels

dimensions. Later, Dycam licensed the technology to Logitech, who marketed the camera targeted to industries needing quick production of photos such as realtors, auto insurance inspectors and the like.

Enter Kodak Photo CD

Prior to the time I was hired by the agency, Kodak launched their Photo CD system (Figure 1-4) in 1992. This system allowed film to be transferred to a digital format in the form of a CD-ROM. The film was scanned by high-end equipment; typically drum scanners, so the resolution and accuracy was far beyond consumer desktop scanners. However, this method came with a price, literally, a very expensive price, depending on which lab you sent your film to for conversion. Typically, the maximum number of photos per Photo CD was 100, and the price ranged from $.50 to $3.00 or more per photo, plus an additional charge for the media and return shipping.

Figure 1-4. Import Dialog Box for Kodak Photo CD Plug-In. Source: About This Particular Macintosh

I remember using Kodak's technology in the early days with my 35mm Minolta Maxxum 7000. Instead of dropping my film off to the local pharmacy for development, I shipped it to a Photo CD service center, where my photos were scanned and transferred to CD-ROM using the Photo CD technology. It took at least two weeks before I received my scanned photos on a CD, which was about the same time I would wait for prints. Getting the prints transferred to my Mac was a bit of a challenge since there was no built-in

transfer software included on the disk. I could view small previews of my photos and import those to my computer, but getting to the high-end file was more of a challenge. As a result, I had to rely on Photoshop and the Kodak Photo CD plug-in to do the heavy lifting (Figure 1-4). The plug-in worked well, and it allowed me to bring in the photo at various resolutions and apply image enhancements in much the same way as Adobe Camera RAW works today.

The problem with the Kodak Photo CD system was twofold. First, it was complicated to use and not very convenient in terms of production turnaround. Second, desktop scanners were becoming less expensive at the time while scanning technology evolved. During the early 90s, you could actually buy a color scanner that could scan in resolutions of up to 300 dpi for around $2,500. For these reasons, Kodak Photo CD never really caught on as a standard solution for digital photography, especially, as scanners quickly gained in technological advancements, and reduced in price.

More Digital Cameras Emerge

In 1994, Kodak forged ahead in the digital camera market and designed the Apple QuickTake 100 camera, (Figure 1-5) which was viewed as the World's first consumer level digital camera under $1,000. The camera had a capture resolution of 640 x 480 pixels, which is equal to 0.3 Mpx. It connected to a Macintosh or Windows computer via a serial cable, and could easily store and transfer up to 8 photos at a resolution of 640 x 480, 32 photos at a resolution of 320 x 240, or a mixed resolution, based on the settings selected by the user. When compared to the film cameras of its time, the QuickTake 100 was extremely limited, especially in its low resolution capturing. But, the convenience of being able to take 24-bit, color images in a pure digital format was ground breaking, even though the price point was fairly high. In fact, Apple introduced two additional QuickTake models, the Kodak made 150 and the Fujifilm made 200, which featured a removable 2MB SmartMedia Card for enhanced storage capabilities. These digital cameras stayed with Apple until 1997, before being cancelled by Steve Jobs, when he returned to Apple.

Figure 1-5. Apple QuickTake 100. Source: Wikepedia – Creative Commons

Kodak made further inroads into the digital capturing world when they partnered with the Associated Press, and jointly created the Kodak/AP NC2000 digital camera. (Figure 1-6) With a capturing resolution of 1.3 Mpx, and the ability to work with an ISO sensitivity of up to 1600, the NC2000 was certainly considered a professional grade digital camera for its time. The original retail price was extremely high at $17,950, not very consumer friendly. But it was enough for The Vancouver Sun to standardize with the camera, and become the first all-digital photography newspaper in history.

Figure 1-6. Kodak/AP NC2000 Source: George Eastman House

Film Hangs In There, Supported by Digital Editing Software

As I explained earlier, though inroads were being made into digital camera technology, the complete adoption of a pure digital workflow was filled with roadblocks, i.e., entry price and low resolution capturing. Film and the traditional dark room approach were still preferred by most professional photographers. But, scanning technologies were rapidly changing, and affordable, high quality drum scanners were emerging, supporting the community of professional and yet traditional photographers, who needed their work converted to a digital format. When I worked at the agency, we used several service bureaus, specializing in scanning and color correcting analog prints and film produced with traditional darkroom techniques. Most of these service bureaus relied on a key piece of software—Adobe Photoshop. This was the go-to tool that took digital photography to a new level, pun intended. The tools built-in to the first versions of Photoshop were very basic, yet powerful. And, as the program developed over the years, Adobe made superb technical advancements with the program, which included layers, plug-in technology, and the like. In Photoshop 4.0, Adobe introduced Adjustment Layers, allowing digital scanning technicians to apply non-destructive edits to their images. This was a powerful feature enhancement that not only allowed the technician to change any aspect of the color corrected and/or enhanced image, but, it also allowed them to dial-up or dial-down the amount of correction via any adjustment slider.

As Photoshop advanced, it was met with some competition. Though Adobe had successfully ported it over to the Windows platform at version 2.5, and introduced layers as a powerful new feature in version 3.0, HSC Software introduced a competing, all be it somewhat expensive alternative – Live Picture. One solid feature in Live Picture was its non-destructive workflow. But, its entry price of $3,995 eliminated it as a true competitor to the more affordable Photoshop. Even though HTC later dropped the price to $995, angering many early adopters of the software, it never caught on to mass appeal.

Quark soon announced their image-editing product named XPosure, which also featured non-destructive editing. But, the program never shipped. Then, in 1996, longtime Adobe rival, Macromedia, introduced their image-editing program named xRes (Figure 1-7). One of the key features of xRes was its speed. The program allowed for fast editing based on low-resolution proxies, which were later applied to the higher resolution version of the image upon final save. But, like LivePicture, xRes never really competed against Adobe Photoshop, now recognized as the industry standard, digital image editing application.

Figure 1-7. Macromedia's xRes Version 2

Faced with competition, Adobe forged ahead with new feature enhancements to Photoshop like support for Camera RAW, the uncompressed and uncorrected format most high-end digital cameras captured natively. Later Adobe introduced new tools like Adobe Bridge, and Lightroom, which further solidified their position as a leader in digital image production and creation. A whole industry was born in a little more than a decade, as Adobe Photoshop dominated the market of digital image manipulation, creation, and enhancements so much so, that the

word Photoshop itself no longer was unique to the name of the software developed by Adobe, but more like a cultural icon, even later, a verb in our common vernacular, i.e. "Did you Photoshop that image?"

As digital cameras continued to evolve, and more megapixels were added to the new crop of digital single-lens reflex (DSLR) cameras, digital photography was taking hold. With capabilities of 6, 8 and 10 Mpx capturing, along with higher ISO rates, better optics and sensors, and lower image to noise ratios, traditional photographers began reacting to the change in the industry. Because of the advancements in both camera and software technology, many traditional photographers began to migrate to digital platforms, literally abandoning the traditional darkroom approach. And, a new crop of photographers emerged – those never trained in traditional darkroom techniques and practices, and, who embraced the new direction of digital photography and creation by diving head first into this exiting world of creative possibilities. This was the path I first entered for photography. A path that soon diverged into a more intimate approach to my art. But, this story is to be told later. First, we need to understand how these early tools began to change the way we approached photography.

Though powerful and liberating, the desktop computer is confining. We are separated from our creative process with tools like the mouse and keyboard. This separation, though subtle, minimizes our true creative freedom. In the next chapter, I'll talk about these issues.

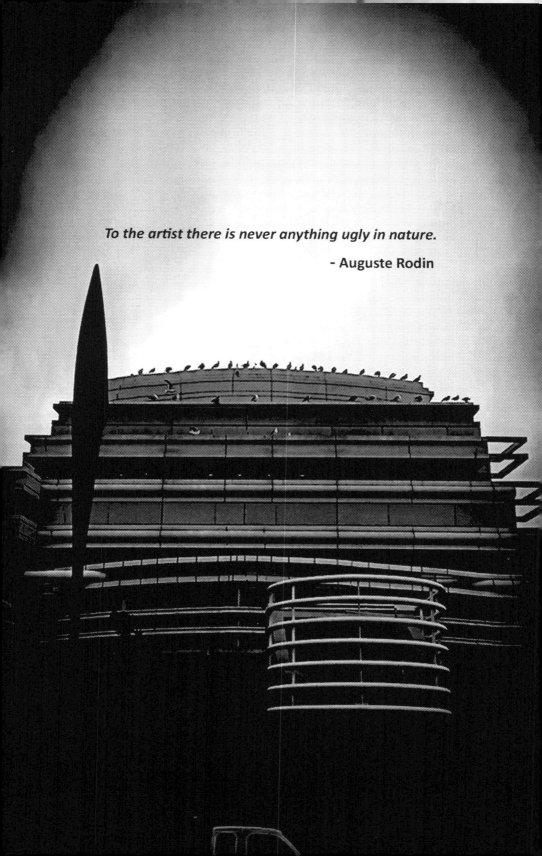

To the artist there is never anything ugly in nature.

- Auguste Rodin

The Lost Connection

Photographers Gain Power at the Desktop, Yet Lose the Connection to Simplicity

Prior to the digital darkroom revolution, photography was more of an art form. Photographers worked with chemicals and papers, and had specialized rooms, dark rooms, which allowed them to control light. They knew exactly which combinations of light, chemicals, and development time achieved a specific goal. They were closer to their art form, exposing their creations by hand in a specialized, tactile way that involved their skill of touch. Yet, as digital single lens reflex cameras (DSLR) and digital editing software advanced, these skills were essentially forgotten since they were not required in this new digital world. As a result, the photographer and artist, though able to achieve things in a faster and even more experimental, technical way, began to lose the intimacy that creative works so often demand. This so called, "lost connection" between the creator and creation was largely unrecognized in the early days of the digital revolution, as the industry began winning the consumer and professional over with more innovation.

From DSLR to Desktop

As we discovered in Chapter 1, traditional film photographers were not ready to take the leap into true digital photography due to price and lack of resolution in the current crop of digital cameras. Nikon can most certainly be credited with breaking this trend when they introduced their Nikon D1 in 1999 (Figure 2-1). Priced at $5,500, the Nikon D1 was a real

bargain compared to the Kodak/AP NC2000, and was the catalyst that toppled Kodak's reign over digital SLR cameras. The D1 delivered what most professional photographers wanted in a camera – the performance of an SLR merged with a higher digital capturing quality. The D1 could capture up to 2.7 megapixels and was built from the ground up as a digital SLR camera, not just a film camera modified with a digital sensor. It was a groundbreaking product. Other competing products followed Nikon's lead, including products from Canon and Olympus. Such advancements in camera technology in such a short time quickly expanded the digital photography market, making such solutions completely viable for the traditional photographer to take the leap from the dark room to the desktop.

Figure 2-1. The Nikon D1. The first pure Digital SLR camera aimed at the mainstream market

Along with the transition to DSLR cameras, photographers were able to tap the power of advanced photo editing applications, such as Adobe Photoshop. Advancements in photo editing software transitioned many photographers away from their dependence on the chemical photographic process, allowing them to create images within a totally digital workflow. This new workflow was actually quite powerful, and allowed photographers to experiment in unique ways. For example, with this new workflow, digital photographers could shoot in full color, understanding that they could

convert the color into a gray scale image within their digital editing software in post processing. No longer was it necessary to first choose black and white film verses color film before a photo shoot if the goal was to end up in black and white, since that goal could be achieved in post-production. As such, post-processing and editing became more important, especially as the tools evolved. Furthermore, post-processing adjustments and/or enhancements could be made on the fly, giving the digital photographer an array of darkroom processes at the touch of their fingertips. Yet, with all the advancements being made in this new digital workflow, like the traditional film approach, there was still a detailed process of getting the images transferred for manipulation (development) and/or enhancement. To this extent, nothing really changed once digital photography entered the mainstream right around the turn of this century.

The Limitations of Input Devices

Most of the early digital cameras used a proprietary serial cable to upload their images to the computer. That is, until USB (Universal Serial Bus) came along, and essentially standardized the transfer method. Today's DSLR cameras also offer wireless transfers via Wi-Fi, which is an added convenience that simplifies the process. However, the photographer is still connected to a limiting workflow:

1. Shooting

2. Transferring

3. Editing/Post Producing

However, there is a fourth piece to this workflow unique to the digital photographer and artist, namely, the input device. There are actually many different types of input devices capable of interfacing with the computer, some of which we learned about in the previous chapter, i.e., scanners and the Kodak Photo CD for example. But, the two most common types of desktop input devices are the keyboard and mouse, both of which replaced the traditional chemical/tactile editing approach of analog photography.

The Keyboard

All desktop computer applications rely on the keyboard (Figure 2-2) to get work done. This might sound obvious, but it is an important thing to keep in mind. The keyboard is our connection to the digital ideas we create on the desktop. Yet, the keyboard can be a barrier to many; a learning curve that must be overcome before a user feels comfortable and in control.

Figure 2-2. The computer keyboard is one of the oldest modern input devices

The Mouse

As an input device, (Figure 2-3) the mouse is a very flexible tool. A small handheld device that allows a user to point, click, select, and drag items on the screen. But, for anyone new to desktop computing, perfecting the use of a mouse can indeed take some time to develop.

Figure 2-3. The computer mouse simplifies interaction with the desktop computer

Other Devices

In addition to common input devices like the mouse and keyboard, other non-common input devices include digital drawing tablets, digital pens, and the more common touchpads, which are now built-in to most modern laptops. Although these input devices have changed dramatically over the years, they are still a barrier for the user; a learning curve they must overcome to operate the device.

The Desktop, a Specialized Creative Space That Confines Us

Before 2007, desktop computing, whether publishing, music composition, or photo editing, was in fact the driving force for many in the creative space. Older photographers adopted a pure digital workflow while younger ones entered the space as "digital natives," harnessing unbelievably powerful tools. For example, Adobe continued to develop their flagship application, Photoshop, with features that were "off-the-chart." Features such as support for the Camera RAW format, spot healing, red-eye reduction, smart sharpening, and later other advanced features like content aware scale, content aware fill (Figure 2-4), shake reduction (for refocusing blurry

pictures), and other features. These advancements ensured Photoshop maintained complete dominance on the desktop as a digital photo and editing creative application.

Figure 2-4. *Adobe Photoshop CC 2014 content aware fill, a powerful image-editing algorithm*

Digital cameras were also advancing around this time. Nikon and Canon began a leapfrog competition with each new camera model they introduced. DSLR cameras were now able to capture video as well. A cottage industry of independent and amateur videographers emerged to challenge professional film companies. These amateurs were able to compete on nearly the same level as mid to low-end film companies with new DSLR camera technology. This so called revolution sounds wonderful, and you might be asking what this all has to do with limiting the desktop creative space? Well, here is the reality: the desktop is the "editing" endpoint, which is separated from the initial creative "capturing" process. Unlike the mobile creative workflow, which we will explore later, the two processes can never truly exist simultaneously. The traditional workflow is to first shoot, next select (which is essentially editing what you've shot) and then finally, process and enhance your selection(s). Within this workflow, the creative process is much more separated and compartmentalized from the photographer and digital artist. It is a process that confines our creativity, and is the opposite of the mobile photography revolution.

Certainly, seasoned photographers have trained themselves to capture the world in a creative way. By no means am I suggesting DSLR photographers are not creative. A simple fieldtrip to Flickr or 500px will set the record straight in terms of the creativity of the DSLR photographer. What I am suggesting is that the process of how we create, in this workflow, forces us into linear thinking. The first step (point A) in the process is the photo session. Here, we look for the subject, or we create it. We then shoot to capture what we see or perhaps imagine. Next, there is the sterile process of transferring what we have captured into the computer. Of course we

can do this today in the field with laptops; however, it is more common to complete this task back in our digital studio. Finally, we edit and choose the shots we like, then, we process them to a final, creative output. Thus, a long line is drawn from the capture point (point A) to the final creative/processing point (point D). As we will soon discover later, mobile photography counters this linear workflow, in that, in many cases, we can actually edit (LIVE) while we capture; thus, merging points A and D into one powerful, creative, and inspiring, non-linear experience. This is the true power behind mobile photography. A power that is freeform, inspiring, and immediate in its interpretation.

This "creative revolution" didn't just happen overnight. It didn't happen when we abandoned our digital desktop workflow, since that workflow is still alive and well today. This revolution happened with the advancement of touch technology made mainstream by Apple with the introduction of the iPhone.

The truth is, as humans, we want touch. We touch our child's head to offer comfort. It is a reassurance; a connection we make. We want to feel. We long for tactile stimulation. True art follows the same path. The closer we are to its source; the more creative freedom we explore. It is the "feel" of "wet paint" on our fingertips that inspires us to create. Touch technology is that so called "wet paint," as we will soon discover in the following chapter.

At the touch of love everyone becomes a poet.

- Plato

Touch Takes Hold

The Introduction of the iPhone and Touch Technology

Digital Photography was alive and well in the mid-2000s. The desktop DSLR workflow dominated the professional and semi-professional photography world, as new digital cameras were introduced and editing software was upgraded. But, the world really belonged to the technical and/or professional user familiar with all the advanced technology and capabilities of that time. The digital photography workflow was dominant on the desktop, aided by the popularity of desktop publishing. Soon, the term "Photoshopping" and the verb "Photoshopped" became a standard way to explain an image that was digitally manipulated, altered or edited in and extreme way. Adobe Photoshop, along with all the latest digital scanners and DSLR cameras reigned supreme in this world. Of course, it was a world largely geared for the economically elite.

The mid 2000s saw an increase in mobile phones incorporating low quality digital cameras as a standard feature. As a result, users could take photos, and even take low quality short videos with some phones, and later transfer their captures to their desktops through cables, via Bluetooth, or share via email.

My first mobile phone that included a camera was the Motorola V551, which I purchased in July of 2005. The camera in the phone was very basic, and maxed out to a VGA (640 x 480) resolution. The camera could capture both still images and video. Because of the quality, I used it more for personal work whenever I was without my SLR camera. Because I carried my phone with me all the time, I soon began using it more often, experimenting, and documenting my life as I went along (Figure 3-1).

Figure 3-1. *A VGA quality shot from my Motorola V551. Having a camera with me at all times soon became a handy way to document my everyday life*

In December of 2007, I upgraded my Motorola V551 to the latest Razr, a V3xx. The phone was thin and stylish, and included a camera that supported up to a 1.3 Megapixel (1280 x 1024) resolution. With more image resolution at my fingertips, I integrated the phone more within my personal lifestyle, further documenting my day-to-day life (Figure 3-2). But the camera suffered greatly in interior settings, falling victim to lowlight noise and incandescent lighting. By then, I had upgraded my Minolta Maxxum 7000 SLR to a more capable Nikon D-50 DSLR, which soon became my workhorse for most of my client work. Still, the Razr was handy when I needed just a quick photo. Little did I know that I was paving the way for the workflow that would soon be transferred to my first iPhone.

Figure 3-2. The image capture quality of my Motorola Razr V3xx was far superior to my V551, which enticed me to use it more often

Enter the iPhone

Steve Jobs first introduced the iPhone at Macworld, in January 2007. It is no cliché to say that the iPhone was a "game changing" device. The interface to the phone was revolutionary, in that it threw away the notion of operating a device exclusively by keyboard input. Touch, which Apple called "gestures," was the cutting edge technology that set the device apart from the competition.

I remember my first experience with the iPhone. Naturally, I was in an Apple Store, and just had to pick up the thing and see what the fuss was all about. It didn't take me long to figure it out. In fact, I remember how intuitive it felt as I tapped icons, swiped, and pinch-zoomed things. Beyond just touching the device, I could interact with it using my body movement, and the iPhone's built-in accelerometer, proximity sensor, and ambient light sensor. The iPhone just felt natural to hold and work with, and it delivered a much different experience than that of my desktop Mac. This is the same experience that is driving the intimacy behind today's advanced touch devices.

Now, it is important to mention, as the self-appointed tech guru in the household, I was not the first one to obtain an iPhone. That recognition goes to my wife, who obtained the phone as a birthday gift in June of 2009. It was an iPhone 3G, 8 GB model, which I immediately took under my "loving wing" and began to test the camera features and capabilities. The iPhone 3G included a maximum 2-Megapixel (1600 x 1200) camera. Not surprisingly, it was more intuitive and natural to operate than my Razr phone in terms of the interface, which was due to its advanced touch technology. Soon, I began to take experimental shots and was blown away by the quality of the results (Figure 3-3).

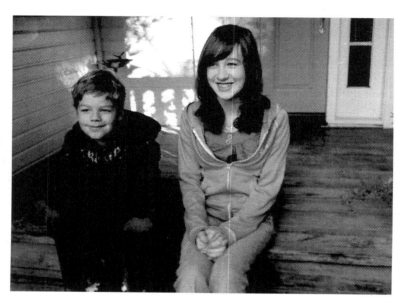

Figure 3-3. A native shot from the iPhone 3G. With a 2-Megapixel resolution, the iPhone 3G began to rival most point-and-shoot cameras

Not to be outdone by the good wife, I soon purchased an iPhone 3GS, 16 GB model, and thus set about the task of incorporating it into my day-to-day lifestyle. The 3GS featured 3-Megapixel (2048 x 1536) resolution, and it included the ability to capture video at VGA (640 x 480) quality, 30 frames per second. This soon became my workhorse point-and-shoot digital camera, which I carried with me at all times (Figure 3-4).

Figure 3-4. A native shot from my iPhone 3GS. At a 3-Megapixel quality, it soon replaced my digital point-and-shoot Nikon 775 camera

The touch-interface of the iPhone made using the device a simple pleasure. No longer did I have to navigate through various menus and dialogs to get to the camera or gallery app. With the iPhone, it was as easy as a tap and/or a swipe to get to where I needed to go. In that respect, the operating system (OS) was out of my way, and thus, didn't impede my creative process. This is an important concept to understand, i.e., as the OS simplified, true creative freedom began to take flight throughout the industry.

The App Store Changes Everything

On July 10, 2008, Apple introduced the App store, just one day before the introduction of the iPhone 3G, and as a result, changed the mobile computing industry overnight. The App Store's concept was to create an environment where developers could create applications for iOS devices using Apple supplied SDKs (Software Development Kits). Furthermore, Apple set up a revenue sharing program with a 70/30 split, in that, the iOS developer received 70% of the profits while Apple kept 30% to manage the App Store infrastructure and promotion. Though the revenue sharing seemed a bit daunting at first, many iOS developers received large financial gains (some in the millions in just the first year) once their applications were created and made available for distribution in the App Store. In fact, ten million applications were downloaded in the first weekend alone after the initial introduction!

Apart from the many productivity, navigation, finance and entertainment applications developed in the first year, camera replacement apps soon began to appear. One of the earliest camera replacement apps that I purchased was an app called ProCamera by German app developer, Cocologics. Some of the key enhancements available in the app were an Anti-Shake mode, digital zoom, tap-to-focus, virtual horizon level, video recording mode, and a photo studio for advanced editing. ProCamera was a fully featured camera app that provided features not available in the factory installed Apple camera app (Figure 3-5).

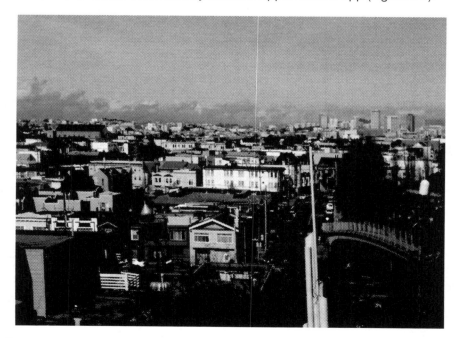

Figure 3-5. Experimenting with the digital zoom function in San Francisco with the ProCamera App

With the success of ProCamera, Cocologics offered several updates for their users until Apple effectively "broke" the app with the introduction of iOS 3. It was actually an intentional move by Apple, in that, with the latest software release, Apple created a restriction for non-Apple camera apps, and refused to include a Camera API (Application Programming Interface). Cocologics had been successful in using Objective-C to modify their UI (User Interface) in a non-standard way that unfortunately broke with the release of iOS 3. Needless to say, there were many unhappy ProCamera owners that soon began to point the finger at the developer. Yet, instead of burying their heads in the sand, Cocologics rallied the troops, and petitioned Apple with other iOS developers, pleading the case for a camera API. Later that year, Apple listened and introduced iOS 3.1, which included a camera API. As a result, the floodgates began to open for third-party photography applications.

A New Workflow is Born

As the App Store began to mature, more powerful applications were introduced, which created a new workflow for the mobile user. No longer did a user need to rely on their desktop computer for basic and even advanced functions, since 2 million apps existed in the App Store at the end of September 2009! This new workflow changed the amateur (consumer) photographic process, effectively eliminating the technical step of transferring photos from the device to the desktop for post processing and editing. With built-in apps, the photographer could shoot, edit, process and share their creations within minutes. This new workflow inspired many app developers to create photo-editing apps that could easily transform captured photos into artistic presentations with a simple touch or swipe of a button. No longer was the photographer required to learn the technology behind transferring their captured photos to their desktop computer, and then editing and post-processing their photos with advanced software like Adobe Photoshop. Instead, their captured photos were already on the editing device, waiting to be imported into a photo-editing app for further enhancement. This was a milestone in workflow evolution, which created true freedom for the artist.

One of the earliest photo editing apps was actually part of a book created by self-taught photographer, Chase Jarvis. The book, "The Best Camera Is The One That's With You: iPhone Photography by Chase Jarvis (Voices That Matter)" maintained the theme that having a camera with you at all times was the best creative workflow. In this case, the camera that Jarvis referred to was the iPhone. With his companion app, Best Camera, users could capture, edit and share their creations through Twitter, Facebook, Flickr and on the BestCameraApp.com website. In my opinion, Jarvis' concept was the first Instagram, targeted at the creative photographer who wanted to be part of a community and share their work.

Early on, I downloaded Best Camera, having read the book, and began to experiment with the tool, which I found to be refreshingly easy, and inspirational. In fact, I credit the app as being one of the first I used and it is responsible for this early "selfie"; i.e., self-portrait (Figure 3-6).

Figure 3-6. A shameless self-portrait (selfie) created with the Best Camera App

One of the cool features of the Best Camera App was its ability to stack filters on top of other filters. Cooling and warming filters along with vignette and border filters were just a few of its 14 standard photo filters that made the photo come alive via a simple touch or swipe of the finger. It was a refreshing app to use.

From this point, other advanced camera apps began to appear with similar functions. Apps such as Camera+ and later Instagram soon created a workflow destined to appeal to the artist within us all. This was the beginning of creative inspiration, and true intimacy and ease of use triggered by mobile touch devices.

The Connection Between the iPhone and the Artist

To understand where we are at this point in time is to understand the impact of our liberation from the keyboard and mouse, two input devices that create barriers between our creative goals. Our minds can think in lighting speed, and as we create, with touch, we are able to transfer this speed into reality more efficiently, and more naturally. Musicians and painters understand this concept, and can quickly transmit their creative intentions to their platforms with ease. Prior to the introduction of touch technology and advanced touch applications, the desktop computer confined us as artists. Only the technical computer user was less confined, perhaps easily navigating the keyboard with shortcut commands or dexterous finger-to-mouse coordination. And, as touch technology expanded, the entry level to reach that creative state was ultimately narrowed and almost eliminated. We were free to explore our ideas with simple swipes and intuitive gestures that working with our devices no longer became a frustration, but a passion. This was the beginning of a new movement that changed the way we create today.

Mobile Disrupts The Digital Change

Don't think. Thinking is the enemy of creativity. It's self-conscious, and anything self-conscious is lousy. You can't try to do things. You simply must do things.

—Ray Bradbury

Part II will provide useful tips for aspiring iPhoneographers and artists, including inspiration, and ways to connect with the community.

True art is characterized by an irresistible urge
in the creative artist.

- Albert Einstein

A New Art Form Is Born

The Art of iPhoneography and Touch Photography

While heading to a client meeting one October morning in 2010, I noticed how dramatic the sun and clouds were contrasted against my client's manufacturing building. Not really thinking, and not wanting to miss the moment, I quickly grabbed my iPhone and snapped a picture (Figure 4-1). Later, in the meeting, we were trying to figure out a great look for my client's new sales brochure. Thumbing through some of the photos and concepts, we soon discovered nothing really jumped out at us. Suddenly, it hit me, and I took out my iPhone and showed my client the photo I had just captured. They were stunned and knew this was the look they wanted. It was at that moment that I truly understood the tiny, creative power I held in my hand. A power now connected to my iPhone.

Figure 4-1. *This was the photo that changed my perception on mobile photography. Not surprisingly, it was the first photo I posted to Instagram when I joined on October 11th, 2010*

In the fall of 2010, a new iOS app created by Kevin Systrom and Mike Krieger debuted. The app was called Instagram, a name derived by fusing the words "instant camera" with the word "telegram." I remember when it was first introduced. No one really understood exactly what it did--other than share photos. In fact, there were already several photo sharing services like Flickr, Facebook, and TwitPic that allowed users to post images from their mobile or desktop devices to share through their social channels. Instagram first aimed for simplification, i.e., a built-in camera for shooting pictures, a few quality retro filters for enhancing them, and a feed where users could follow other users and interact with the photos posted. One other wrinkle Instagram threw into the mix was allowing only a square format when posting. Many users were confused; some turning up their nose to the limitation, but the idea was to emulate old-style vintage cameras, like the instant Polaroid cameras of the late 60s. Like Twitter, Instagram had followers, and similar to Facebook, users could show their appreciation of a photo by tapping the "heart" button. Similar to Flickr, Instagram was focused on photography. For me, I quickly understood the concept behind Instagram since I had been using the Best Camera App for some time now. I was immediately hooked.

With the release of Instagram version 7.5 in August of 2015, users were no longer limited to posting only square format images. However, many users still prefer the traditional square format.

By this time, I had upgraded my iPhone 3GS to a more capable iPhone 4 that featured a capture quality of 5-megapixels (2592 x 1936), along with a high quality retina display. Like my 3GS, I carried my iPhone 4 with me everywhere. I had filled the phone with an abundant collection of photo apps from panorama apps, to special effects apps, to HDR (High Dynamic Range) apps, and more. I literally had a portable photography studio in the palm of my hands. It was a liberating experience. Whatever the mood, wherever the scene; I was able to capture it and share it in an instant.

Instagram began to shape a new way of photographic communication. With the ease at which anyone could take a photo and process it with built-in, high quality filters, the app was an instant hit. Soon, Instagram artists began to emerge, gaining massive amounts of followers. These artists began to experiment in ways never before seen in the photographic world, focusing on concepts and stories wrapped within a single, visually pleasing photo. Because the device they were using was intimate and personal, the art and photography they created became more honest and inspiring.

Intimate and Personal, Our Camera is Always with Us

Centuries ago, after the invention of the printing press, the freedom to publish our opinions, thoughts, and ideas was in the hands of the masses. This same concept can be paralleled with the rise of mobile phones, and mobile photography today. With a camera always by our side, we are able to capture our world literally within moments of our perception (Figure 4-2). From there, we can share what we experience in a more natural, and immediate way (Figure 4-3). The device becomes an extension of our perception, and with it, we create our perceived reality (Figure 4-4). We interpret, explore, experiment, and ignore. Yet, the freedom to express our self is limitless. This is the intimacy and inspiration behind iPhone photography (iPhoneography).

Figure 4-2. While visiting Avebury England in 2011, I was taken by the ancient stone monoliths surrounding the town. After taking this shot, I processed an extreme edit with an app called Pixlr-o-matic by Autodesk, Inc.

Figure 4-3. A quick capture of my son enjoying the cool waters of our local swimming pool in summer. Shot with my iPhone 4

Figure 4-4. *A snapshot of an old London building with a vintage effect applied via the ClassicINSTA app. Shot with my iPhone 4*

Our Experience is Tactile, We Create with Touch

Touch inspires us to create. It is a simple connection we make between the iPhone's screen and our fingertips. Soon, the door opened as the art form of iPhoneography via the iPhone was born. It is a new movement that introduced the world to a different kind of creative experience (Figure 4-5). With iPhoneography, the photographer is able to capture photos and edit them on the same device (Figure 4-6). The only input devices are the lens and the touch from the artist. It is a far more efficient, and pure way, to reach one's creative goals, and it opens up doorways for users isolated by the

technology behind the traditional digital photographic process of shooting, transferring, editing and sharing. At this point, the process approaches a singular event that frees the artist and photographer from dealing with the creative delay and from dealing with the technology behind desktop photography. Thus, iPhoneography is pure, instant, and honest (Figure 4-7). This is what sets iPhoneography apart from any other photographic method.

Figure 4-5. The Grand Carousel at Place de la Concorde in Paris. Shot with ClassicINSTA on my iPhone 4

Figure 4-6. The Stage is ready for the Phantom of The Opera at Her Majesty's Theatre in London. Shot and edited with my iPhone 4

Figure 4-7. Carefully sneaking up to my dog as she napped, I quickly captured her blissful moment. Further edits were made with Tilt Shift Generator App. Shot and edited with my iPhone 4s

An Intimate Workflow

The iPhone is an intimate device that we keep close to us, and use whenever we feel a creative spark. With the simplicity of its touch user interface, our creativity is limitless and free. It is a device that inspires us to explore, invent and dream. The doorway to creation is no longer dominated by the technically minded. The simplicity in touch lets anyone join and create.

From 2009, new creative photo apps were introduced to the iOS App Store as the iPhone continued to gain in popularity. Advanced apps like Filter Storm Pro, which featured hi-resolution editing and correction tools plus layers (Figure 4-8), FX Photo Studio HD which featured numerous

tools and special effects filters (Figure 4-9), and the Camera+ app, which featured advance shooting, filters, and editing tools plus a unique clarity (HDR simulation and enhancement) feature (Figure 4-10), were just a few of the new apps being introduced. Other shooting apps were aimed at specific interests. For example, the vintage camera app, Hipstamatic, which debuted in 2009 (Figure 4-11) was aimed at recreating that retro feel through simulated analog film filters--complete with lenses, film rolls, flash kits and sound effects.

Figure 4-8. A screenshot from an early version of Filter Storm Pro. Photo credit, Life In Lofi iPhoneography

Figure 4-9. *FX Photo Studio was a powerful editing and effects app available for both iPhone and iPad devices*

Figure 4-10. *A screen capture from the 2012 version of Camera+ by Tap Tap Tap, an advanced shooting app that included a unique clarity enhancement feature that brought out amazing detail in a raw captured photo*

Figure 4-11. *A screen shot of the front end interface for the Hipstamatic app. Users could change the lens by swiping it, or change the film by tapping the film icon. The app became a favorite "toy camera" app within a year of its debut."*

Touch is Familiar and Natural

When we interact with the iPhone, iPad or similar mobile device, it is a familiar and comfortable experience. We don't have to adapt to the device because the device easily adapts to us. Our fingertips control our experience as creative impulses are transmitted along the median and ulnar nerves to the brain and back. We can swipe, point, tap and pinch with one two or three fingers as we interact with our device. Yet, the index finger alone is our most dexterous and sensitive finger. It is the one we use the most to interact with our mobile device. In fact, Apple has integrated touch-id into the iPhone since the 5s, furthering the idea that touch is where it begins.

Ancient Yogis understood the power of touch as they developed mudras (hand gestures) to stimulate certain points (chakras) along the body during Yoga practices. With specific finger combinations, the Yogis believed energy points could be triggered. In fact, one of the mudras, referred to as the Gyan Mudra, which stimulates the Ajna Chakra that controls knowledge and creative ability, is a similar gesture we use to hold a pencil, crayon or paintbrush (Figure 4-12).

Figure 4-12. The Gyan Mudra controls the Ajna Chakra as a focus point, believed by Yoga practitioners to stimulate knowledge and creative ability

Painters and artists experience a connection with their art, interacting with it through the paintbrush, crayon, chalk, pen, or fingers. This connection, which is made through the fingertips as the artist holds the pen or brush, is the same connection the iPhoneographer shares with their mobile device. The same stimulation a painter or artist experiences is being sent through the neurons from the fingertips to the brain. It is no wonder that artists and painters soon developed an attraction to iPhone technology; especially as

new apps were introduced that were essentially hybrid photo and painting apps. This new breed of apps allowed the iPhoneographer to literally paint over their photos using brushes and similar effects found in desktop design and painting applications (Figure 4-13).

Figure 4-13. A creative photo composite of my son by the river, using a method referred to as app-stacking, which is the filtering and combining of a series of post-processed shots using various specialized iPhone apps

For me, my experience with iPhoneography in its early days was liberating, inspiring, and intimate (Figure 4-14). With the camera always by my side, I would capture the world around me; and, with the growing library of shooting, editing and creative apps I collected, I began to express myself as an iPhoneographer and artist (Figure 4-15). The practice of iPhoneography is stimulating and rewarding, and is something anyone can learn with the right tools and knowledge. This is where the next chapter and beyond will take

you as I explore techniques, applications, methods, guidelines, experiments and creative "happy" accidents that will take your iPhoneography to new levels.

Figure 4-14. A candid photo of my wife, snapped on my iPhone 4s, edited and enhanced in Snapseed, and post-processed in the Repix app

Figure 4-15. A photo shot with my iPhone 4s post-processed with the Mextures app

Every artist was first an amateur.

- Ralph Waldo Emerson

Tools, Tricks and Techniques for Creative iPhoneography

Learn the Methods of Good Photography and Composition

Today, a new age of creativity opens as we transition from the desktop to a more mobile and touch enabled workflow. Though the desktop workflow is still alive, we now have the choice to utilize it alongside our new mobile workflow, or venture off solo into uncharted waters. Moving from the confines of the desktop to the freedom of mobile and touch means we have to craft and refine our technique. One way we accomplish this is with creative tools that take us beyond our wildest imagination. Apart from the many apps we want in our grab bag, we also want to understand techniques, secrets, and doorways into creativity. This is exactly what this chapter will detail–the tools, tricks and techniques for Creative iPhoneography and art.

The Master Shot

It is important to start your creative process with a high-resolution photographic capture, which I refer to as the master shot–a high-resolution raw composition shot with proper exposure, lighting, and contrast,

preferably captured unfiltered, and unprocessed. The idea is to start with a high quality capture so you will be able to apply edits, crops, adjustments, filters, or special effects to this base image that you later re-edit, or recompose into a new creation. While it is perfectly acceptable to shoot with apps that immediately apply effects, like Hipstamatic, it's best to leave the effects processing for after the fact.

> I love Hipstamatic's combination of lens and film packs. With version 300, you can now change lens and film AFTER you have made the shot!

Typically, a good camera app can create a solid master shot. You want to make sure that the app can save at the highest resolution possible, which in some cases can be TIF format. I'll detail my recommended shooting apps shortly, but keep in mind, if you are comfortable shooting with a particular app, as long as it can save a high quality unprocessed capture, you'll have a solid master shot from the start.

Inspiration

The easiest way to find inspiration is to photograph what you love. Unlike a commercial photographer who is commissioned to shoot a specific subject, you have the freedom to find your inspiration. For example, I love to photograph large bodies of water against clouds because I enjoy the reflections and ripple effects that the subject produces. If you enjoy being around people, try portrait photography. If you enjoy solitude, try landscape photography. The point is, when you appreciate what you are photographing, it will show through in your final composition. I'll talk more about inspiration in the next chapter.

Composition

Composition in photography is an important concept to understand. There are many ways to achieve great composition in your photos by applying some basic rules and specific techniques as well as studying other photographer's and artist's methods to spark your inspiration. What exactly is composition in iPhoneography? Is it like photography, painting, or art? Do we approach it as a photographer, a painter, or an artist when we begin

to compose? In my opinion, it doesn't really matter, since composition is largely visual, and thus, something that applies to photography, painting and art. It is the way as a creative that we arrange what we see, (or what we think we see) into a representation of what we want others to see. It involves paying attention to subtle details like lighting, shapes, colors and objects, and maintaining a unique understanding of how those elements combine to create a whole. While there is certainly a science behind composition, don't abandon chance, blind luck, or improvisation when working with composition. In other words, there is no "right" way to use composition, but there are a few rules you can apply that will help make your compositions stand out. Please note that these are perhaps soft rules as they are not hard and fast rules and perhaps would be better named "guidelines". But for the sake of uniformity, I am going with "rules" in this book.

Rule of Thirds

The Rule of Thirds is a long-standing composition rule that artists, painters, and photographers have used to create their compositions. Essentially, the rule states that you compose your visual image by dividing it into nine equal parts – drawing three equally spaced horizontal lines divided by three equally spaces vertical lines. At the point where the horizontal lines intersect with the vertical lines is where you place your elements of interest (See Figure 5-1). It doesn't have to be perfect, but if you apply the rule of thirds while shooting and editing, your iPhoneography will gain new life. One tip to keep in mind when shooting is to enable the grid in your shooting app whenever possible–this can help you apply the rule with less effort. Most shooting apps have an option to turn on the grid. At first, it might seem distracting, but after a while, you'll get used to shooting with it. Also, most crop tools will automatically display a grid when activated, so you can crop and align your photo and apply the rule of thirds as you edit.

Figure 5-1. The Rule of Thirds is a composition guideline that creates the overall visual from a nine-part grid, keeping elements of interest along the intersecting lines of the grid

Lines, Curves and Shapes

Lines can lead your viewer through your image, towards a particular direction, balance, or divide your composition, while curves can define shapes and shadows in your work. In landscape photography, imaginary lines can be visualized–for example, the horizon line against the setting sun in the ocean. In portrait photography, the curve of your model's face can capture the light in such a way as to define the shape of the face. When composing your shot, look for relationships in lines, shapes or curves that help define what you want to capture, or lead the eye to your intended target (See Figure 5-2). Use the grid to make sure your lines are straight whenever possible. The exception to this rule might be if you drastically tilt your lines for dramatic effect, rather than slightly tilting them. Slightly crooked lines

can be visually displeasing to most viewers. As we will learn later on in the chapter, some editing apps offer ways for you to straighten your image in post-processing, which gives you the ability to fix a crooked horizon, for example.

Figure 5-2. Using the rail lines paired with the natural forest ending line on the right, I've created guiding lines that focus the eye's attention towards the vanishing point in the distance

Balance

When you arrange or position your elements, another effective technique is to use *balance* to define your composition. Unlike negative space, which I will talk about shortly, balance evens out the open space into a more logical visual representation. Your subjects do not have to be the same size, weight, height, or color. In fact, sometimes you can balance your

composition with opposites (See Figure 5-3). You can also combine balance with the rule of thirds, lining up elements in the grid in opposite points on their intersecting lines.

Figure 5-3. Balance keeps the visuals in your composition even and logical. Here, I've balanced the larger, yet lighter, open flower on the right with the smaller, yet heavier, closed flower on the left

Negative Space

Leaving intentional emptiness in your image is another effective composition technique. Negative space simplifies your image to its root concept. You don't have to capture every aspect of your subject, or its environment. As it has been said, less is often more, and often draws the eye to a simple focus for a subtle effect. Giving your subject room to exist in your composition affords the eye a chance to imagine something more (See Figure 5-4).

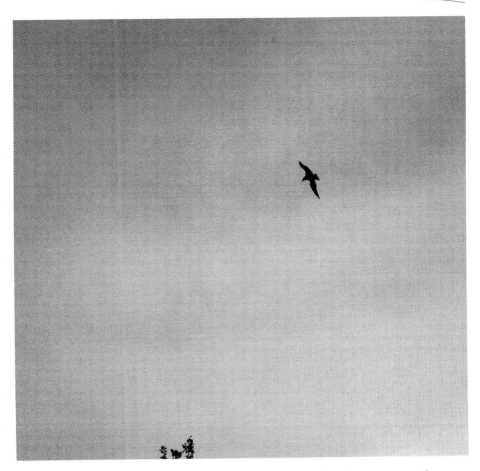

Figure 5-4. The negative space surrounding the bird and treetop gives the eye a sense of vastness–room to dream

Color

Using color in composition brings out specific moods and feelings. For example, the color blue is calming and cool, and brings forth a sense of tranquility, whereas the color red is rich and fiery, and emits a sense of energy and comfort (See Figure 5-5). Color can be vibrant or monochromatic in your compositions, and, as we will explore in the next chapter, it can be used to define a specific theme. In arts like painting, drawing and design, color theory plays an important role in how the artist perceives, and later implements his or her vision.

Figure 5-5. The color red is the compositional element here

Light

Light as a compositional technique can elicit dramatic feelings and moods to the eye. In the studio or indoors, light is often controlled and manipulated against the subject to reveal a softness, or harshness, depending on the artist's vision. Outdoors, lighting can be random, yet predictable, like sunrise or sunset, at which time the angle from the sun's rays casts pleasing shadows for that perfect capture. Though today's mobile phones continue to perform well in low light conditions, they still prefer an environment rich in light. As an iPhoneographer, you should pay attention to how light interacts with your subject. Composing with light involves precision and timing, as well as chance and luck; yet, understanding how light plays against your subject is key to creating a great composition (See Figure 5-6).

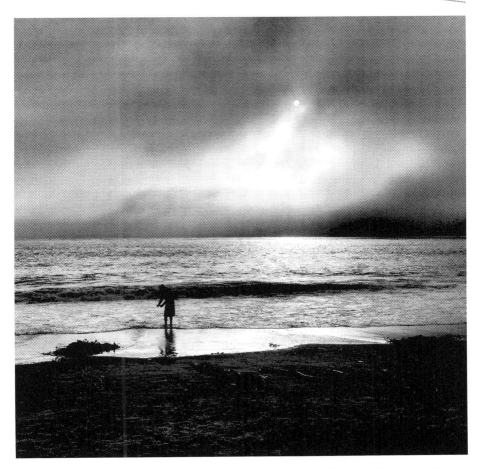

Figure 5-6. During a vacation in Carmel, California, I snapped this silhouette of my son on the beach. The natural lighting from the sun against the waves and shoreline added to the dramatic composition

Depth

Depth can be used to focus the eye on your subject, or to expand the vastness of your composition. In traditional DSLR photography, a wide aperture with a closer focus will produce a shallow depth of field (the area that is in focus), whereas a narrow aperture with a broader focus will produce a greater depth of field. Creating a shallow depth with an iPhone can be difficult since the lens has a fixed aperture, meaning it can't be adjusted. Typically, the iPhone captures a greater depth of field, keeping almost everything within focus. As a creative tool, shifting the focus to a specific subject can add emphasis and importance. One method of creating

a shallow depth of field uses a process called tilt-shift, which blurs a specific area of the image while maintaining a sharp focus on another. Many iPhone editing apps have tilt-shift filters and tools that you can utilize to create a shallow depth of field. Additionally, dedicated "focus" apps like Enlight, BigLens or Afterfocus allow you more precision through the creation of masks and simulated aperture adjustments (See Figure 5-7). Depth can also be used as a composition tool to express a vastness and openness to the eye (See Figure 5-8).

Figure 5-7. A garden turtle ornament is the focus here after using BigLens to mask and blur the background. The iPhone is currently unable to capture a narrow aperture at this level

Figure 5-8. A sense of depth is created in this composition by utilizing a deeper focus that encompasses the car and trees in the distance. Source: Michael Clawson

Symmetry and Patterns

Like balance, *symmetry* and *pattern* are effective composition tools. Symmetry is replication–a reflection of one side of your composition against the other, whereas pattern is an element that repeats. Start by studying the world around you, taking notice of repeating patterns and reflections in buildings, stairways, or similar subjects. Even in nature, symmetry and pattern can be discovered (See Figure 5-9). There are also several apps such as SparkMode that can generate symmetry through mirroring and repeating patterns (See Figure 5-10).

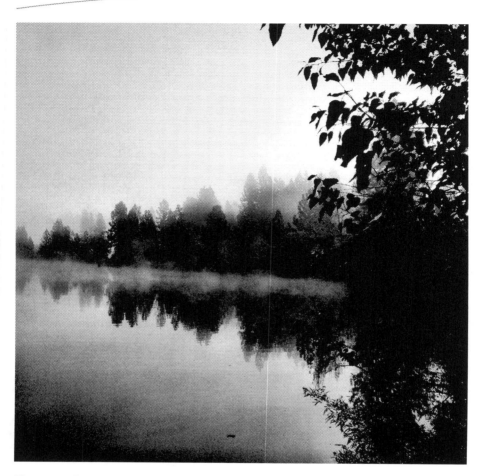

Figure 5-9. Patterns in nature can reveal symmetry, and be utilized as a composition tool in iPhoneography

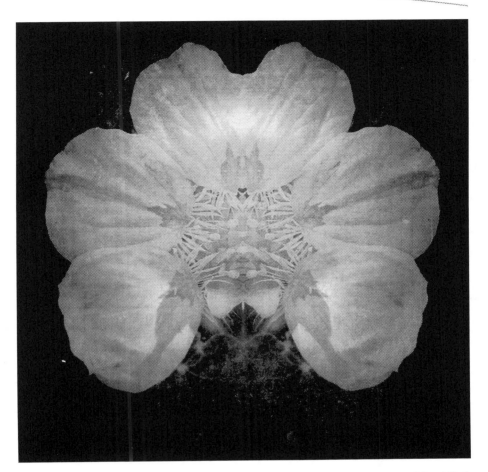

Figure 5-10. Symmetry can be generated with the aid of an app, in this case, I've used SparkMode to develop a symmetrical image from a flower that creates the illusion of a dancing divinity

Framing

There is that cliché image of a comedic movie director, holding out his fingers in the shape of a square as he squints to frame his proposed scene that is actually not far from the idea behind framing. Jokes aside, framing plays an important role in composition. When you set up your shot, study what surrounds your subject – is there a natural frame like a tree or window that can encompass it? Is there a distraction on the edges of your subject's frame that might be minimized or removed simply by changing your angle slightly? Take the time to artfully frame your subject (See Figure 5-11). This can create a better composition as opposed to just composing and shooting

quickly. Keep in mind; framing can also be dealt with during post-production via cropping, and or adding custom framing effects like borders or vignettes in editing apps.

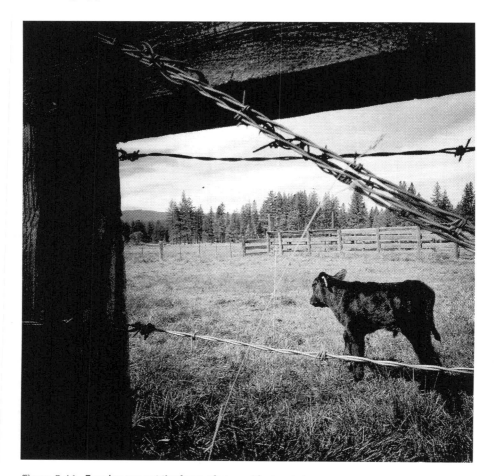

Figure 5-11. Framing can set the focus of your subject and story

Break the Rules and Experiment

I'll never forget what my college drama teacher taught me one day in his office while he was reviewing one of my creative writing assignments from another class. After reading my paper, we discussed aspects of writing in terms of the so-called "right way" to approach a character for believability and acceptance from the reader. But soon, he looked me in the eyes and told me to remember three simple rules:

1. Know the rules

2. Break the rules

3. Get away with it

Since then, I've used this mantra throughout my life as a creative. Rules are important to understand and follow, but if everyone followed the rules all the time, life would be boring and similar. Good art takes risks and challenges us to think in different ways. In applying what you have learned so far, don't be afraid to experiment with new ideas of your own. This is how you grow as an iPhoneographer.

Must Have Apps for Creative iPhoneography and Artistry

As of this writing, there are over 1,300,000 apps in the App Store, of which approximately 12,031 fall in the category of photo and video. Figuring out which app to buy when faced with such a number is a challenge. However, good apps often rise to the top through App Store ratings, editor's picks and reviews. Just because an app doesn't have a lot of reviews doesn't necessarily mean it is useless. I've often bought apps I've never heard about that looked interesting only to discover they are now popular in the app store. While it's difficult to highlight every app, there are a few standout apps that every iPhoneographer should have in their arsenal. I've divided them in three distinct app categories – shooting, editing and special effects.

The current number of iOS Apps can be referenced through Wikipedia on the App Store page. However, calculating the number of photo and video apps is tricky. I found a few resources, one of which is called 148Apps which returned a number of 12,031 as of this writing. You can do a search for photo and video at (http://www.148apps.com/search/Photo+and+video) if you are curious as to the present number of photo and video iOS apps.

Shooting Apps

There are actually many high-quality shooting apps available in the App Store. The key takeaway about a good shooting app is the capture resolution. Most good camera apps can capture at the full resolution of the device. The full resolution is typically a high-resolution JPEG (Joint

Photographics Experts Group) format, which is a "lossy" format, meaning the image is compressed to conserve disk storage space on your iPhone. To make matters worse, as you edit your photo and save it back to your camera app, the iPhone saves it again as a lossy, JPEG format. This process introduces something called "generation loss," meaning, the more you edit and export your photo, the more quality you will lose in the process. This is why it is important to start high, and stay high, minimizing exports as much as possible.

Many apps now offer non-destructive editing of your original image capture. What this means is any edit you make to your original capture can be "undone" thereby giving you the ability to restore your image to its original state. I'll discuss this concept in more detail shortly.

Camera (iOS 9)

The iPhone's native Camera app is a solid camera app. In fact, I use it to capture most of my initial shots because I can access it fast, and it's packed with features such as tap to focus, exposure and focus lock, manual exposure adjustment, grid, HDR (High Dynamic Range), timer, panorama mode, burst mode (for quickly capturing up to 999 photos in one shutter release), video, slo-mo, and time-lapse. To quickly access the native camera app from a locked screen, all you need to do is tap the camera icon on the lower right of your phone's lock screen and swipe up (See Figure 5-12).

Figure 5-12. To easily access the built-in camera of your iPhone, simply tap the camera icon on the lower right of your phone's screen and swipe up

Before shooting with the Camera app, it's a good idea to modify the settings in the Settings app.

TO SET UP THE CAMERA APP FOR OPTIMAL SHOOTING:

1. Tap the Settings app.

2. Locate the Photos & Camera tab.

3. Swipe your finger up until you see the Camera section (See Figure 5-13).

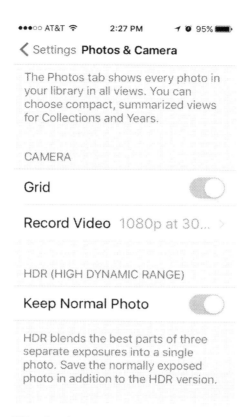

Figure 5-13. Applying additional settings to our stock iOS Camera App

4. Turn on Grid (This helps visualize the Rule of Thirds).

5. Turn on Keep Normal Photo (This keeps a normal photo when using HDR mode, which is handy if your HDR photo is blurred from movement).

6. Set your preferred video capture resolution based on the capabilities of your device.

7. Exit by tapping the Home button.

Since the Camera app is easily accessible from the home screen, it makes sense to use it as your primary shooting app. Switching between the different camera modes is accomplished by swiping your finger left or right, or simply tapping on the mode name on the bottom of the app's view screen. The Camera app will automatically search for a focal point, which is indicated by a yellow focus square. You can also focus on a specific point in the viewfinder when you tap anywhere on the screen (See Figure 5-14).

To manually adjust the exposure, tap on the exposure slider on the right of the focus square (which is the slider with the yellow sun icon) and slide up to lighten the image (over expose) and down to darken it (under expose). One other cool trick is to lock the exposure and focus by holding your finger down to any point on your screen until you see the AE/AF Lock, which is a yellow indicator, at the top of your screen (See Figure 5-15). With the focus and exposure locked, you can further adjust the lighting with the manual exposure slider. Keep the same distance from your subject and try a shot from a different angle such as from the right, left, top or bottom. Since the exposure is locked, the lighting should remain the same when you position your iPhone to get that perfect composition.

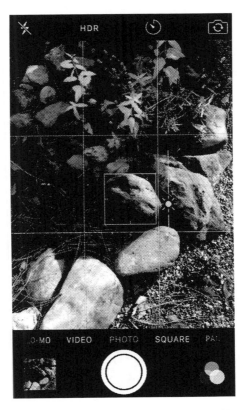

Figure 5-14. Tapping on your subject will manually focus your point of interest. Moving the exposure slider up will lighten your image while moving it down will darken your image

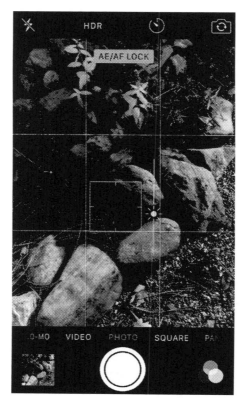

Figure 5-15. Holding your finger down to any point on your iPhone's screen will lock the exposure and focus to that point. You can still adjust the lighting further with the exposure slider on the right

Additional Shooting Modes in Apple Camera App (iOS 9)

There are a few other modes in the stock Camera app that are available in the top menu bar (See Figure 5-16). The first mode, activated by the lightning bolt icon, is the flash control, which includes three options – *Auto*, which senses the light in a given situation and fires the flash as needed; *On*, which fires the flash every time; and *Off* which disables the flash altogether (See Figure 5-17). The second mode, activated by the HDR button, controls HDR** shooting (See Figure 5-18), which includes, Auto, a mode that activates HDR shooting based on the lighting dynamics of the scene, On, a mode that enables HDR shooting all the time, and Off, a mode that disables HDR shooting. The third mode, activated by the clock icon, controls the Timer (see Figure 5-19), and includes the option to set a 3 or 10 second interval before the camera takes a single photo; or, a quick burst mode** series

of 10 pictures if you have an iPhone 5s or greater. Finally, the fourth mode, activated by the camera icon on the top right, toggles between the front facing FaceTime camera and the rear facing iSight camera.

Figure 5-16. The Camera app's top menu bar includes from left to right, flash control, HDR control, timer control and camera orientation control (i.e., front camera or back camera)

Figure 5-17. The Camera app's flash control menu. A yellow highlight indicates the mode is active

Figure 5-18. The Camera app's HDR control menu

Figure 5-19. The Camera app's Timer control menu

HDR stands for High Dynamic Range. With the Camera App, it involves the quick capture of up to three different exposures that are combined into a final image that displays a scene in a fuller "dynamic" range. Traditionally, a photographer chooses to compose an image by adjusting for the highlights or shadows of the given scene. Mobile phones often struggle in high contrast lighting situations; however, by employing HDR shooting, a scene's lighting can be captured closer to what the human eye can naturally perceive.

You can take a burst mode shot at any time on an iPhone 5s or greater by simply holding your finger down on the shutter button. As long as your finger engages the button, the camera will continue to take pictures until it reaches 999 shots. The burst mode session is recognized as a single shot in your camera roll. To review the session, tap on the single image, and choose the Select . . . option on the bottom menu to reveal all the images in your burst session. Your iPhone intelligently gives you recommendations of your best shots indicated by a gray dot on the bottom of each shot. You can tap on the clear circle on the bottom right of any image to 'check' it as a selected shot. When you hit done on the top right menu, you can keep everything, or keep only the shots you have selected (favorites). Burst mode is great for capturing fast action, as well as portrait photography.

CAMERA+

As you learned in Chapter 3, the original Camera app that shipped with the iPhone was a basic shooting app, and was soon minimized by more powerful camera apps available in the App Store. Though iOS 9 has made the Camera app much more powerful (see above), the evolution of third party camera apps continues. One of my favorite third party camera apps is Camera+ by Tap Tap Tap, which features numerous shooting and non-destructive editing** features. Since the introduction of iOS 9, Camera+ can take advantage of the new Camera API, which adds manual adjustment features like ISO, white balance, shutter and focus. You can purchase Camera+ in the App Store at http://campl.us.

Download for iOS
http://campl.us

Non-destructive editing means edits are applied to the original image as adjustments rather than "burned-in" to the photo, effectively destroying the original. Since the edits are only adjustments, you can easily remove them and start over with new edits.

Some of the key features in Camera+ include:

1. Separate focus and exposure reticles, which can be locked in place while shooting (See Figure 5-20).

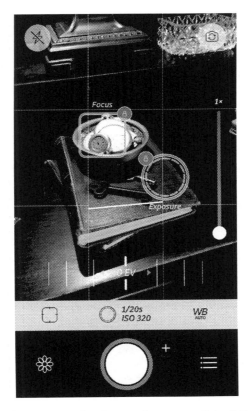

Figure 5-20. Camera+ features separate+ focus and exposure reticles that can be moved, and locked independently on the screen

2. Advanced shooting modes, which include Stabilizer, Timer, Burst and Macro, as well as an auto crop mode, which can be enabled while shooting for shooting square (1:1), normal (4:3) or wide (16:9) ratios.

3. 6x Zoom with advanced digital processing.

4. White Balance +Presets for automatically or manually adjusting the white balance before the initial shot.

5. Photo Flashlight mode, which engages the flash as
 a continuous fill light rather than a quick burst during
 the shot. This is handy for illuminating your subject
 even in daylight, and is great for portrait and macro
 shooting.

6. Manual Shooting Mode, which allows you to make
 independent ISO, Shutter and Focus adjustments
 while shooting.

7. A built-in Lightbox for organizing, editing, managing,
 and sharing captured images (See Figure 5-21).

*Figure 5-21. The Lightbox in +Camera+ allows you to organize, edit, manage and share your
captured images*

8. Scene Modes for quick adjustments like Auto, Scenery, Portrait, etc.

9. Crop Mode, which allows for custom non-destructive cropping of your captures shots.

10. The Lab – A non-destructive editing workflow that includes Clarity Pro (See Figure 5-22), an adjustable HDR-like effect that drastically increases the quality of your original shot. The Lab also includes a Straighten editor, Tint and Duotone editor, as well as additional tools like Soft Focus, Film Grain, Sharpen, Blur, Saturation, Temperature, Exposure, Brightness, Highlights, Shadows, and Vignette.

Figure 5-22. Clarity Pro in Camera+ is +an adjustable HDR-like effect that drastically increases the quality of your original shot

11. Over 40 Adjustable 1-Touch Filters that can be layered to add stunning effects to your photos (See Figure 5-23).

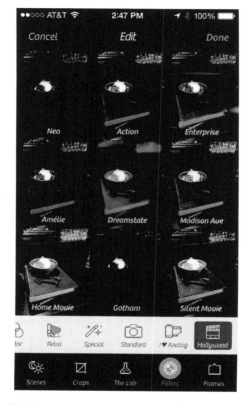

Figure 5-23. Camera+ includes 45+ adjustable filters, which can be layered to create stunning shots and special effects

12. Frames and +Borders – you can choose up to 27 different styles of frames and borders.

ProCAMERA

Another fantastic shooting app packed with features is ProCamera (available in the App Store at http://procamera-app.com/appstore). As you recall from Chapter 3, ProCamera was one of the first alternative camera apps available in the App Store. Since then, the developer has continued to add features and advancements. Though ProCamera has similar features to Camera+ such as manual adjustments, lab, effects, lightbox, timer, stabilizer to name a few, there are some unique features worth mentioning.

Download for iOS
https://itunes.apple.com/us/app/procamera-+-hdr-photo-editing/
id694647259?mt=8

Additional features of ProCamera vs Camera+ include:

1. Video Mode, which can be configured to capture 24, 25, 30 or MAX fps (frames per second) while shooting. The Video mode also includes adjustable exposure and focus reticles and digital zoom.

2. HDR Mode, an in-app purchase of vividHDR (which I'll discuss below) that integrates fast HDR capturing inside ProCamera.

3. Night Mode, which features adjustable shutter speeds for optimal night photography.

4. QR Code Scanner, which allows you to read QR codes, bar codes and more.

5. Advanced Image Format, which allows you to save your photos in TIFF, TIFF LZW (a compressed TIFF format) and JPEG format.

6. 3D Tilt Meter, that aids in+ the alignment of your shot, even if your phone is tilted.

vividHDR

One of my favorite HDR shooting apps is vividHDR (available in the App Store at https://itunes.apple.com/us/app/vividhdr/id681849185?mt=8). As an HDR shooting app, vividHDR is very fast, yet manages to capture a high dynamic range in a series of 3 or 5 quick variable exposure shots. The app features several HDR presets that include Natural, Lively, Dramatic, Bleach and Gray Art (See Figure 5-24). It is a fun app to shoot with since it produces stunning results (see Figure 5-25). Furthermore, vividHDR can be configured for a non-destructive workflow called "Lazy HDR" (see Figure 5-26) which allows you to apply a different HDR effect after your initial capture to any image in your lightbox. Like the factory Camera app, I recommend you configure vividHDR to save the original, non-HDR image to your camera roll as well.

Figure 5-24. vividHDR's presets include Natural, Lively, Dramatic, Bleach and Gray Art

Figure 5-25. vividHDR produces stunning results as a dedicated HDR capturing app

Figure 5-26. vividHDR's settings can be configured for non-destructive editing in "Lazy HDR" mode, as well as save in TIFF format

Download for iOS
https://itunes.apple.com/us/app/procamera-+-hdr-photo-editing/
id694647259?mt=8

Look for additional recommended apps in the Appendix section of this book.

EDITING Apps

Many photographers believe that good photography happens during the capture process, not the editing process. Yet, in the early days of mobile photography, applying a filter edit often enhanced the low-resolution capture from an older device. Today, as devices become more powerful and capable of capturing in a higher quality format, "hiding" a device's shortcomings is not always needed. Still, a good mobile photographer needs to understand

how to enhance their original capture–taking it beyond their vision. Today's editing apps are powerful, and capable of taking an average capture to a higher level.

Photos (iOS 9)

Since the introduction of iOS 8, Apple discontinued iPhoto for iOS, but incorporated much of its capabilities in the new Photos app. The Photos app now includes a non-destructive editing workflow, which is ideal for keeping the quality of your edits high, as well as giving you the flexibility to make changes and adjustments, or start over from scratch without destroying the original image. The Photos app editor includes color and lighting adjustments, cropping and straightening adjustments, built-in filters, and the ability to use third-party filters and editors from other supported developer apps.

To access the Photos editor, tap a photo in the Photos app and tap Edit in the top right menu. There are three simple, yet powerful, editing options in the Photos app–Light, Color, and B&W (See Figure 5-27). You can adjust your edit with precision by tapping the menu button (the down arrow in a circle) to the right of the adjustment. Once you expand the adjustment menu, you can make precision adjustments to fine-tune your effect (See Figure 5-28). To use a third-party editor, tap the button on the top right (three dots in a circle) and select an editing app (See Figure 5-29). To add additional apps to the list, slide your finger to the right and tap More, then tap the "on/off" switch to green to add the app to the Photos app filter editor list. Note: if an app doesn't show up in the list, then the developer has not yet optimized it to use the new iOS 9 API (Application Programming Interface). With an external editor selected, you can apply additional non-destructive edits to your photo not available in the standard Photos app editor (See Figure 5-30). Finally, you can easily remove your edits by tapping Revert on the bottom right menu bar (See Figure 5-31).

Figure 5-27. The editing options in the Photos app include Lighting, Color and B&W

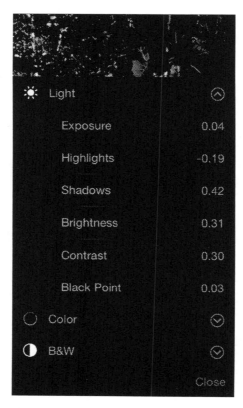

Figure 5-28. Precision adjustments in the Photos app can fine-tune your effect

Figure 5-29. Adding an external editor to the Photos app

Figure 5-30. Applying Afterlight's crest filter within the Photos App

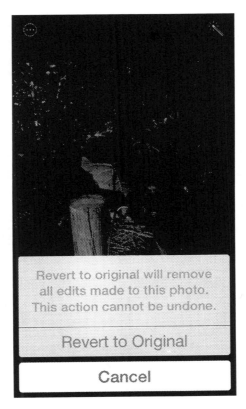

Figure 5-31. Clearing out edits is achieved by tapping Revert on the bottom menu bar in the Photos app

Snapseed

First developed by Nik Software in 2011 then later acquired by Google, Snapseed is a solid editing app. The strength of the app lies in its modular approach to editing that allows you to progress linearly or non-linearly through its various editors to make precision adjustments or add special effects. Snapseed includes 9 task specific editing tools (See Figure 5-32a) and 12 advanced filter modules (See Figure 5-32b) with most featuring a wide range of parameter adjustments. Once you have selected a tool or filter, tap and swipe your finger up or down to activate the modal menu to fine-tune the module's adjustments (See Figure 5-33).

Figure 5-32a. Snapseed features 9 task specific editing tools

Figure 5-32b. Snapseed features 12 advanced filter modules

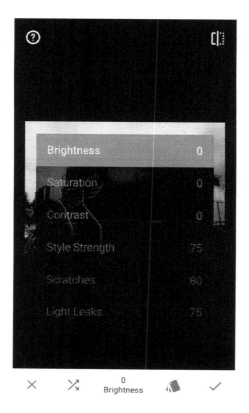

Figure 5-33. Most tools and filter modules in Snapseed include precision adjustments that are accessed through a modal menu once you tap and swipe up or down

Snapseed also supports non-destructive editing via "stacks" which keep track of your applied edits, allowing you to re-edit or export your filter session for use on a new image. One of the coolest things about Snapseed is all of its editing power is available for free!

Download for iOS
https://itunes.apple.com/us/app/snapseed/id439438619?mt=8

Download for Android:
https://play.google.com/store/apps/details?id=com.niksoftware.snapseed

Attention Android users: After acquiring Snapseed from Nik Software in December of 2012, Google integrated many of Snapseed's features into their Photo service, and created a stand-alone Android version with an identical feature set to the iPhone version!

VSCO Cam

VSCO Cam is a shooting and editing app similar to Camera+ and Pro Camera. For that reason, I should have included it in the shooting apps section of this chapter since the app now incorporates many of the new iOS 9 camera features like adjustable shutter, ISO and focus. However, one thing that really shines in the app is its subtle, yet unique film quality filters and adjustments (See Figure 5-34). In its raw form, digital photography is almost too perfect and sterile, lacking the nuances of traditional film such as grain, and subtle color tones. VSCO Cam returns theses nuances with an array of film quality filters and editing adjustments. And, like Camera+ and the Photos App, VSCO Cam features a non-destructive workflow. The app includes a few film quality filters for free, and you can add additional filters through in-app purchases in the VSCO Cam store. In addition, the app is also available for Android.

Figure 5-34. VSCO Cam's film quality filters and adjustments can give your iPhone images a more traditional look

Download for iOS
https://itunes.apple.com/us/app/vsco-cam/id588013838?mt=8

Download for Android:
https://play.google.com/store/apps/details?id=com.vsco.cam&hl=en

SPECIAL EFFECTS

Sometimes you need more than just editing your captured photos–you need something special. There are numerous creative apps that can process your image in a painterly style, in a grunge style, as a drawing, as geometric shapes, or many other variations in between. These special effects apps can be employed to create unique results on their own, or used in combination with other apps, as you'll learn in the next chapter. For now, let's take a look at some of the standout special effects apps currently available.

Mextures

One of my favorite special effects apps, Mextures, is an app actually designed by photographers that includes over a hundred refined textures such as analog light leaks, grunge and gradients, emulsions, grits, and grains, that are largely scanned from real 35mm film. Creating a unique look is easy; and, can be achieved by either applying any of the preinstalled formulas, or starting from scratch with your own selection of textures, gradients and effects. Further enhancements can be made to your overall look via the Adjustments menu. Mextures employs a layering approach (which we will explore in the next chapter) and allows you to stack unlimited effects and textures over your original image. The end results are often one of a kind (See Figure 5-35).

Figure 5-35. *With Mextures, you can create a layered composition with a unique feel, and save your edits as a formula to reuse or share online. Here, I've created a Mexture formula with the code NKSMALW. To access it in Mextures, tap the beaker icon on the bottom left of the launch screen, then tap the red plus button and enter the formula code*

Download for iOS
https://itunes.apple.com/us/app/mextures/id650415564?mt=8

Fragment – Prismatic effects

Fragment - Prismatic Effects turns your images into artistic prisms and shapes randomly, or by the touch of your finger. Developed by Pixite Apps, makers of the popular Tangent, Fragment offers a set of prism filters that mirror and reshape your image into a fragmented remnant of the original (See Figure 5-36). You can capture an image with the camera or import it for manipulation. The app uses frames, patterns and shapes to rearrange your image, which you can further manipulate using blurs, colors, fades, levels and blending modes. This app can produce stunning results that are practically impossible to duplicate. Fragment is available for both iOS and Android.

Figure 5-36. Fragment app produces unique and creative imagery using frames, patterns, textures and prism effects. Here, a photo of a dandelion is reimagined

Download for iOS
https://itunes.apple.com/us/app/fragment-prismatic-effects/id767104707?mt=8

Download for Android
https://play.google.com/store/apps/details?id=com.pixite.fragment

ALIEN SKY

Alien Sky is a visual effects layering app created by developer BrainFeverMedia, that features pre-masked effects like planets, moons, and stars along with lens flare and nebula effects that can be layered over captured or created images (See Figure 5-37). The app includes basic layer masking so you can blend your effects for a more realistic look and a set of filters and editing adjustments to fine tune your effect. As a special effects app, I've often used it to create my overall base image that I then take into to Mextures or VSCO Cam for finishing touches.

Figure 5-37. Alien Sky includes fully masked planets, moons, and stars along with lens flares and nebula effects that can be combined to create out of this world imagery

Download for iOS
http://www.brainfevermedia.com

Advanced Editing Power

Enlight

When I first saw Enlight, I was teaching an iPhoneography class at MacWorld in March of 2014. The app was in beta form, which means it was not yet ready to be officially released. Yet, even in this form, the app blew me away with its capabilities! The app is similar to Snapseed, and features module adjustment modes. However, a key feature built-in to the app is precision masking in almost every filter. This feature alone reminds me of layer masks in Adobe Photoshop, which give you incredible power to precisely apply your edits to all or portions of your image. Enlight features eight editing tabs similar to Snapseed's modules. The tabs are organized by specific capabilities such as canvas adjustment and refitting; image adjustment and enhancement; filters and color effects, healing and reshaping; artistic painting and sketching; drawing and text; and framing (See Figure 5-38).

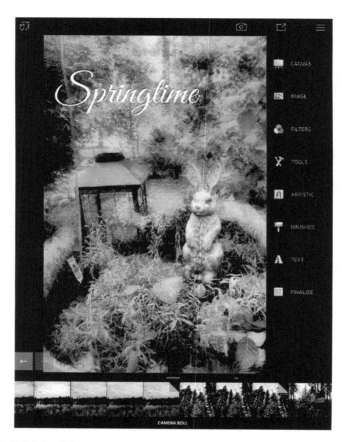

Figure 5-38. Enlight's editing tools give you a wide range of capabilities that you would normally achieve using multiple apps

Download for iOS
http://www.enlightapp.com

Peaceful Coexistence

The knowledge you've gained in this chapter is a great steppingstone towards your path as a creative iPhoneographer. The iPhone has come a long way, and is more than just a toy–it's an artistic tool that fits into any creative's workflow. When the iPhone replaces the DSLR is not the question– how it can coexist in the world of other digital capturing devices is the real idea. When the World Wide Web first opened to the public, the question was how soon it would replace print, radio and television. Twenty-three years later, the World Wide Web has developed as its own medium alongside

print, radio and television. In other words, nothing has been replaced. Thus, iPhoneography, and in its broader sense, mobilephoneography or smartphone photography, is not simply a fad that will soon disappear. With the evolution of devices and the introduction of new technologies, and the advancements in mobile workflows, iPhoneography has a bright future.

As you develop your iPhoneography skills, be open to new ideas and new techniques. In the next chapter, we will explore other ways of thinking, and new approaches that will help you see beyond your vision.

Vision is the art of seeing what is invisible to others.

- Jonathan Swift

Seeing Beyond Your Vision

More Techniques and Hands on Exercises To Develop Your Creativity

Training ourselves to see things differently is key to creating something new and alive. We might be inspired by sunbeams on a table, raindrops on a leaf, or a smile from a best friend. Yet, sometimes, it is not obvious. Training yourself to see the oak grain within the brilliant glow of sunbeams, a tiny ant dancing within a raindrop ocean, or a toothy grin that reveals the character behind a smile is seeing beyond what our vision reveals. It is paying attention to subtleties in pattern, shape, color, light and movement. How does one develop an eye for seeing things differently? It starts by simply looking up, down, left, or right as we journey throughout our day, training our mind to see first what our eyes put before us last. We must look, think, and look again.

As you make your journey and seek your vision, keep your smartphone near, like a little secret friend ready to capture your inspiration. See, think, look, and capture, or reverse the order and experiment. Here you are developing your art form. There is no real pattern or rule on how you attain your vision simply because your vision is unique and connected to you. Your job is to share your vision with the world.

THOUGHT EXPERIMENTS

As you begin to develop your vision and style, it is a good idea to experiment with techniques you've learned from the previous chapter along with some of the techniques in this chapter.

Seeing with your mind is a very important technique to develop. Our eyes are the "lenses" connected to our brain through which we interpret our perception. As we look through these lenses, we send feedback to our mind, which immediately begins to interpret that input. We may interpret the visual data as unimportant, and move on to the next image. In fact, this is a common occurrence in our everyday life. What is uncommon, and something we should constantly strive for as mobile artists and photographers is the ability to see magic in the ordinary. Of course, there is no real roadmap or rulebook as to how this is achieved. Instead, we need to rely on techniques and methods that help stimulate this discovery. One thing we can do to help initialize this thought process is to provide a visual idea. We can achieve this through thought experiments.

COLOR VISUALIZATION

Try this simple color experiment. Go inside and/or outside and look for a specific color like red, green, or blue. Pay attention to every subtle shade, including light and dark contrast. Try to ignore any other color than the one you choose. Once you are focused, close your eyes and see it in your mind. Let your imagination wander and focus on where it takes you next. The point here is to just let go – let things happen and evolve. Sometimes we spend too much time critiquing our perceptions; saying to ourselves "that photo is not good," or, "I just can't capture the right moment." If we approach our iPhoneography this way, nothing we do will ever bring us satisfaction.

Green Visualization Experiment (Figure 6-1 through 6-4).

In the following examples, I have chosen the color green for my visualization quest. This should give you an idea of what to look for when visualizing color. In other words. As you can see, I have not limited my color visualization to organic forms. The point here is to pick a color and capture it in a series with your smartphone or device.

Figure 6-1. Green Visualization Experiment Image 1, Leaf

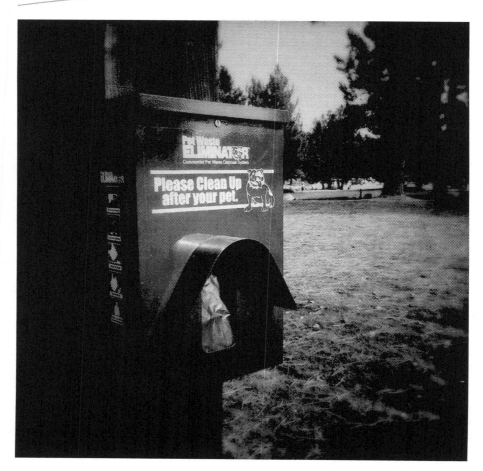

Figure 6-2. Green Visualization Experiment Image 2, Green Pet Waste Clean Up Box

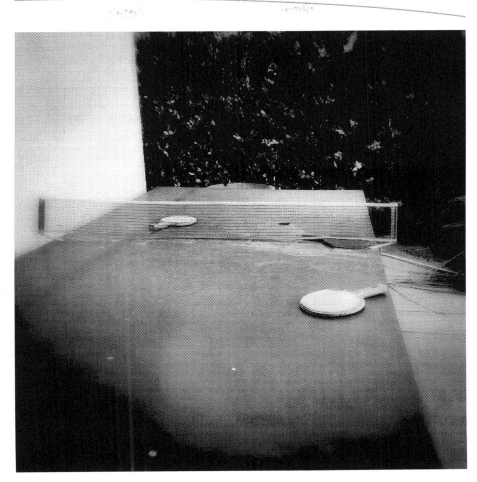

Figure 6-3. *Green Visualization Experiment Image 3, Green Ping Pong Table*

Figure 6-4. Green Visualization Experiment Image 4, Green Bus

DIRECTIONAL VISUALIZATION

Here is another experiment involving direction. In this exercise, the goal is to focus on things in a particular direction as you look through the camera lens. The direction can be above, below near or far. For now, pick a single direction and focus on it like you focused in the previous color exercise. Take your smartphone and focus on that direction as you look through its lens. I know this sounds rather obvious, but the point here is to pay attention to a particular angle, both through the camera lens, and alternatively with your eyes, as you discover an interesting point of view. For example, I spend a lot of time looking at trees and clouds since I love the soft contrast of fluffy white clouds and painted sky when captured in a composition against the silhouette of a dark tree line. Yet, when I'm in the city, I employ this same technique to buildings, paying attention to what lies above. You could reverse this direction and spend time close to the ground, observing "the tiny things" in life hidden from the world above. Again, don't force your visualization; let it come naturally, even if you accidentally look the opposite way, that's okay. Maybe your subconscious mind is trying to tell you "there is something important in that direction–pay attention!" Then, once you

discover something, try looking at it through your smartphone. Directional visualization gives you a general goal and purpose as you start to capture the world around you. It is another simple exercise you can utilize to further develop your inspiration and creativity.

Directional Visualization Experiment (Figure 6-5 through 6-9).

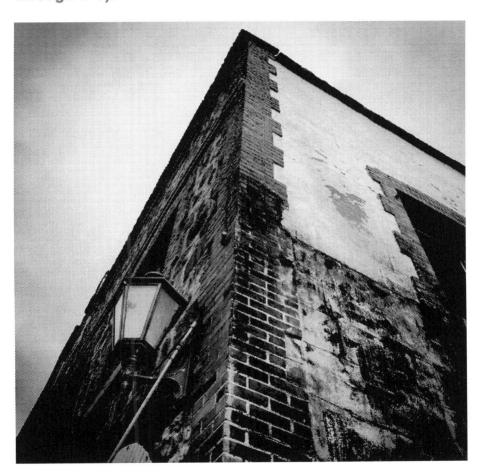

Figure 6-5. Directional Visualization Experiment Image 1, Burned Building

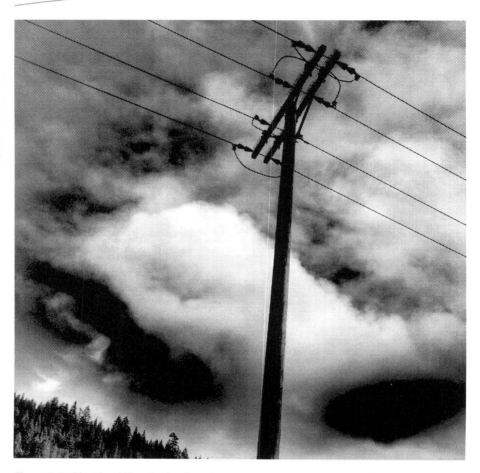

Figure 6-6. Directional Visualization Experiment Image 2, Telephone Pole and Cloud

Figure 6-7. Directional Visualization Experiment Image 3, Golden Treetops

Figure 6-8. Directional Visualization Experiment Image 3, Golden Gate Beam

INSPIRATION

At some point in our life, someone, or something has inspired us. Whether it was a friend, parent, teacher, song, book or photograph, inspiration is a direct pathway to our creative mind. As aspiring or established artists, inspiration is essential. As a thought tool, inspiration can spark the connection from our mind to our ultimate creative vision. Of course, we don't need to be artists to be inspired. Inspiration can apply to anyone. But, with iPhoneography and mobile photography, inspiration can lead us to areas we may have never imagined.

One simple way to get inspired is to pay attention to people whom inspire us. We can do that through various methods, but one easy way is to follow the people whom inspire us in your social media channels like Facebook, Twitter, Instagram, etc. I will detail the differences between many of the social sharing services aimed at the photographer and artist in the next chapter, but for now, try this exercise. Find five new mobile artists and/or photographers in your social media channels and follow them. One way to locate new artists might be through friends you already follow, since most social media services allow you to view your friends' friends, as well as the people they might be following. But, don't just follow new people because your friends are following them. Take the time to view another body of work, and see if it interests or inspires you first.

Once you have discovered a few new and inspiring people, the next step is to study them. Do they have a particular style? Do they portray a particular theme? What do you like about their approach? What do you think they might change? Once you have observed them, and filled your mind with questions, see if you can answer them on your own. Look for clues as to how they have achieved their art form. Perhaps they detail their process, which makes it even easier to understand. Once you feel you understand their process, try emulating it. Don't copy it exactly, but experiment with their approach. The more you experiment, the more you learn how to recreate a technique or style you prefer. A while back, I did this with portrait photography, emulating some of the techniques from a select group of portrait photographers I admired and followed through my social media channels. Eventually, I was able to develop a portrait style that fit my approach to iPhoneography (Figures 6-9 to 6-11).

Figure 6-9. Directional Inspiration - Portrait Image 1, Musicians Two

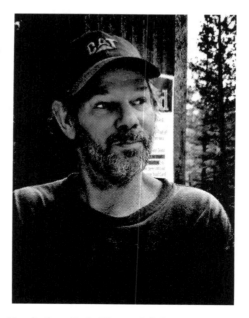

Figure 6-10. Directional Inspiration - Portrait Image 2, Bob

Figure 6-11. Directional Inspiration - Portrait Image 2, Tess

IMAGINATION

Our mind rationalizes the world around us, interpreting what we see based on what we understand, or have learned. Imagination expands our rationalization, and connects us to something altogether new. We solve problems with imagination; answering questions that we may already know, but perhaps have never asked. As artists and mobile photographers we use our imagination in many ways, sometimes to communicate our emotions or the emotions of our subject. Sometimes our imagination takes us into places of joy and bliss. Sometimes our imagination takes us into areas unfamiliar and dark. Our mind sets us apart from any other animal because we can think, dream and imagine. Using imagination in our iPhoneography and mobile photography is a key step towards seeing beyond our vision.

There are many exercises to expand our imagination: reading a book; writing a story or poem; listening or performing music; drawing or painting images; and of course, photographing and editing with our mobile phones. We must look, think and look again; then, we must imagine and create. This is the true art of iPhoneography and mobile photography. It is more than simply taking a picture with our mobile phones. The art of iPhoneography is capturing our vision through our imagination, and then sharing it with others.

TOUCH EXPERIMENTS

Throughout Part I, you learned the evolution from the desktop to mobile, and in Chapter 4, you discovered how touch has revolutionized the way we create. Now it is time to take that a step further by learning through experience.

TOUCH EXPERIMENT 1: PORTRAIT EDITING

For this exercise you will need a good portrait image as a starting point. You could use your own image if you prefer, or you can use the image I provide for this exercise which is located in the Source Code/Downloads tab on the book's web page at http://www.apress.com/9781484217566. *You will need to add the image I have provided to your iPhone's camera roll.*** To edit the photo, we will be using Facetune, an excellent portrait editing app.

Download for iOS or Android
http://www.facetuneapp.com

Adding a photo to your iPhone's camera roll that was not created on your device is fairly straightforward. To do this, launch Safari on your iPhone and locate the URL (the web link) that points to the image in the paragraph above. Once the image has loaded in the browser window, tap and hold your finger over the image until you get a dialog box that asks you to 1) Save Image, 2) Copy, or 3) Cancel. Choose Save Image, and the image will be added to your camera roll on your iPhone.

PORTRAIT EDITING WITH FACETUNE

1. Open the Facetune App

2. Tap the camera icon in the top left of the screen and choose Open Photo.

3. Locate the portrait image you added to your camera roll using the image provided for this exercise and then tap to open it.

4. Along the bottom of your Facetune app screen, you have a selection of tools specifically designed to enhance and edit portrait photos. You can use your finger to slide the tool bar left or right to expose additional tools like Tones, Red Eye, Defocus, etc.

5. Tap Whiten and paint across the model's teeth with your finger to whiten her teeth. Repeat this step for the whites of her eyes. To zoom in, pinch/zoom with two fingers. (Figure 6-12) Once you have whitened the teeth and eyes, tap the blue check button on the top right of the screen to accept your edits.

Figure 6-12. Whitening the teeth in Facetune

6. Next, use the tools slider and load the patch tool. The patch tool allows you to patch areas of and image, like a blemish or scratch, with a clean area on the image. It's similar to the clone stamp in Adobe Photoshop. In this case, tap on a blemish on the model's forehead and move the circle around with your finger until the blemish is erased using a clean (cloned) area of the image. (Figure 6-13).

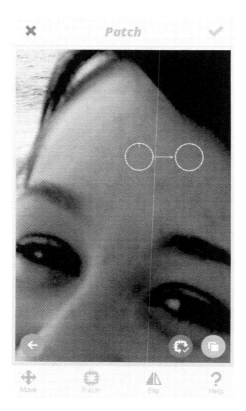

Figure 6-13. Using the patch tool in Facetune to edit blemishes

7. Once you have applied the patch to a blemish, tap the red incremental edit check button on the bottom right of the screen, next to the light blue, compare original button, and continue editing your blemishes. If you make a mistake, you can tap the left arrow button on the bottom right to go back, or tap the red X on the top left of the screen to start over from where you were before tapping the patch tool. Once you are happy with your patch tool edits, tap the blue check button on the top right of the screen to add them to your session.

8. Next, tap the smooth tool and softly smooth the model's forehead with your finger. You can smooth her nose and cheeks if you want. The smooth tool blends the image together. The more you apply, the more "plastic" your model may look, so use it sparingly. Once you are satisfied with your smoothing edits, tap the blue check button on the top right of the screen to accept the edits (Figure 6-14).

Figure 6-14. The final effects of the smooth tool in Facetune

9. Once we have made our minor edits to our model, we are ready to apply some filter effects to finish off our portrait photo. On the bottom of the screen, slide your finger to the Filters icon and tap it to open up the editing panel. With the Filters panel, we are able to apply numerous effects to our photo that range from Paper styles to Lighting Styles, Textures, Lens, and Masking.

10. Tap the Lighting button and select Lighten. With your finger, swipe to the right to apply an overall lighting effect to the image. In this case, we are going to apply a Lighting effect level of 100 on the image to brighten our model's face. Notice that when we do that, the highlights in the background are completely washed out (Figure 6-15). Don't worry. We will fix that in the next step with the Masking option.

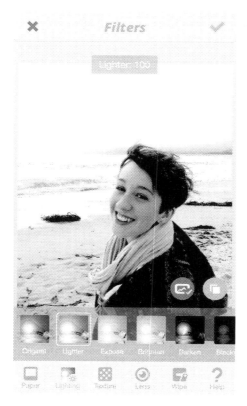

Figure 6-15. After applying the Lighting effect, our model's face looks better, but our background is completely washed out

11. Tap the Wipe button to bring up the Masking effects. In the panel, you will see four buttons just above the main editing buttons. These buttons are labeled Wipe, Apply, Fill and Clear. As you swipe your finger, the Wipe button "wipes" away the effect, returning the image to the state prior to the effect's application. The Apply button simply applies the entire effect to the image. The Clear button clears the effect from the image. So, you use the buttons to add or subtract the effect by either applying the whole effect or using your finger to precisely add the effect.

12. With the Wipe button active, tap the Clear button to clear the effect. When you tap the Clear button, you'll notice that the Apply button is automatically selected. This makes sense; since we want to apply the effect to specific areas of our image, in this case, with our finger, we will paint the effect on the model. Make sure you only apply the effect to the model and not the background image (Figure 6-16).

Figure 6-16. By using the Wipe tool, we can apply the lighting effect only to the model

13. Once you have applied the Lighting effect to the model, click the red incremental edit check button on the bottom right of the screen to accept the edits but continue adding filter effects.

14. For our final filter effect, tap the Textures button and swipe your finger along the effects option until you find the Studio effect. Now, swipe your finger to until the strength is around 80 (Figure 6-17).

Figure 6-17. Adjusting the Studio effect to a strength of 80

15. Tap the Blue check button on the top right of the screen to apply the effect, then tap the Share icon on the top right of the screen to save your final edited image to your camera roll (Figure 6-18). You can also tap the Blue before/after button on the bottom right to see what your image looked like before your edits.

Figure 6-18. *The final Facetune edited portrait photo*

TOUCH EXPERIMENT 2: LAYERING

As we discovered in Chapter 1, you learned about the addition of layering features in desktop software like Photoshop and Xres. In Chapter 5, you learned about some of the top iPhone apps, some of which include layering. Before layering was introduced to iPhone Apps, iPhoneographers used a technique called "App-Stacking;" a technique I was first introduced to by Digital Photographer and Artist, Dan Marcolina in his book, "iPhone Obsessed." Essentially, "app-stacking" involves the culmination of consecutive edits from a series of iPhone creative apps. The technique is actually quite effective at producing unique edits of a particular subject, theme, or photo. The workflow involves editing, and then re-editing of a photo using a series of specialized photography or art apps. In that sense, "stacking" is essentially "layering" images one over the other. In this tutorial, you will learn the fundamentals of "app-stacking" and layering.

To begin this tutorial, locate the Landscape image in your resources folder which located in the Source Code/Downloads tab on the book's web page at http://www.apress.com/9781484217566. You will need to add the image I have provided to your iPhone's camera roll with the method I explained earlier. The tutorial will involve several apps, including, Snapseed, Image Blender, and Mextures.

SNAPSEED STEPS:

1. If you haven't already, follow the steps in Chapter 5 to download Snapseed for free.

2. Open Snapseed.

3. Locate my original photo you saved to your camera earlier. You can also use a photo of your choosing if you prefer.

4. As you learned from Chapter 5, Snapseed is a very powerful editing app that includes some very interesting filter modules. For the first 'layer' of our final image, we want to use the HDR Scape filter. Tap on the Edit Button (the pencil icon on bottom right of your screen) and the find HDR Scape filter.

5. Tap HDR Scape to activate the filer.

6. If you tap Style, you will notice several presets. We will be using the Nature preset to process our image. Tap to make sure Nature is selected, then swipe with your finger, to the left to reduce the strength of the filter to about 50. You can also experiment with a higher effect value if you prefer.

7. Further adjustments can be made to the image when you place your finger on the image and swipe up to activate the modal menu for the HDR Scape filter. Here, you can adjust the Filter Strength, Brightness and Saturation (Figure 6-19).

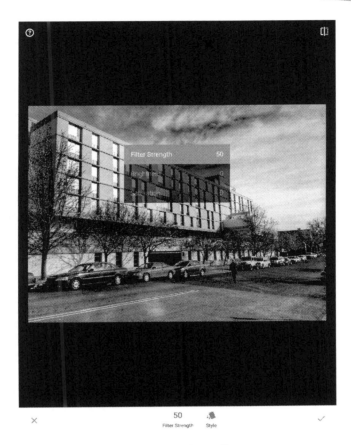

Figure 6-19. Adjusting modal settings for the HDR Scape filter

8. Click the gray check button on the bottom right to accept the HDR Scape filter adjustments.

9. Though Snapseed can use a "non-destructive" workflow, and we could layer multiple filters on top of the other, we want to export this current state to our camera roll so we can modify and combine it with other edited versions using different apps. This step creates our first layer or "stack" for our app-stacking technique. Tap the SAVE button on the top right and tap Export to save a copy with permanent changes.

10. Next, you will create your next state by tapping the Noir filter. To activate the filter, tap the Edit Button (the pencil icon on bottom right of your screen) and the find Noir filter.

11. Once you have activated the Noir filter, tap the Style button and choose S01.

12. Swipe up to open the modal menu and swipe left to adjust the brightness to -10. Then swipe up and select Wash and adjust it to 100 (Figure 6-20).

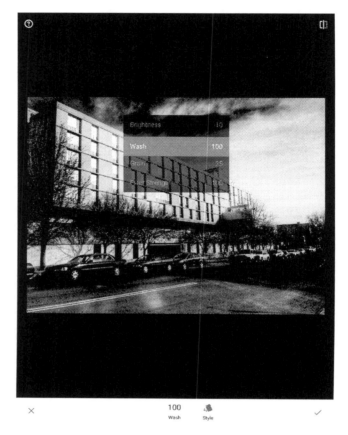

Figure 6-20. Activating the Noir Filter in Snapseed and adjusting Brightness to -10 and Wash to 100

13. Now, we want to apply a more dramatic effect to our black and white layer stack. Tap the edit button and find the Lens Blur filter. Tap it to activate the effect and move and reshape the Elliptical blur over the man entering the building. You can reshape the ellipse by pinching with two fingers. Next, swipe up and set the Blur Strength to 12 and Vignette Strength to 50 (Figure 6-21) and tap Save and Export your image. This is now your second layer stack.

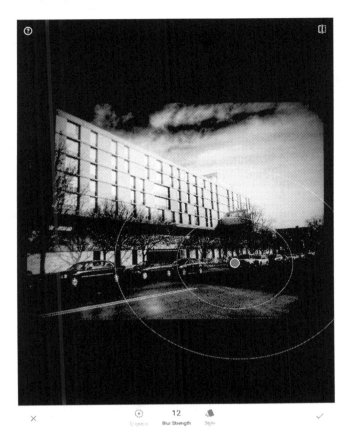

Figure 6-21. Adjusting Snapseed's Lens Blur effect

IMAGE BLENDER STEPS:

1. Now that we have created two layers with Snapseed, we need to combine them with a very simple layering program called Image Blender. You can find Image Blender in the App store at `https://itunes.apple.com/us/app/image-blender/id414544492?mt=8`

2. Once you have installed Image Blender, open it.

3. With Image Blender open, notice the small squares on the left and right separated by a slider? Basically, these squares are containers for two images that you will blend together using the slider and additional blending effects.

4. First, tap the bottom left square button and tap Library to locate the HDR Scape color image from the previous exercise. Tap to add it to Image Blender. (Figure 6-22).

Figure 6-22. Loading our first image layer (The HDR Scape Layer) into the Image Blender App

5. Next, tap the bottom right square button and tap Library to locate the black & white lens blur image from the previous exercise. Tap to add it to Image Blender (Figure 6-23).

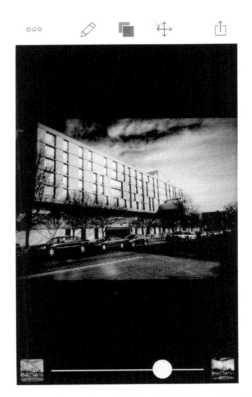

Figure 6-23. Loading our second image layer (Black and White Lens Blur) into the Image Blender App

6. With the slider, we can adjust the strength of each image by sliding to the left, to increase the left images strength, or sliding to the right to increase the right images strength. But first, we want to adjust the Blend Mode, which is accessed by swiping up with our fingers. There are several blend modes that determine how the second image blends with the first image. These modes include: Normal, Multiply, Screen, Overlay, Darken, Lighten, Color Dodge, Color Burn, Soft Light, Hard Light, Difference, Exclusion, Hue, Saturation, Color, Luminosity, Plus Darker, and Plus Lighter. What we are after in this case is the Luminosity blend option, which will maintain the color of our bottom layer but use the black and white image as a "light guide" to dramatically alter our image into a more cinematic effect (Figure 6-24).

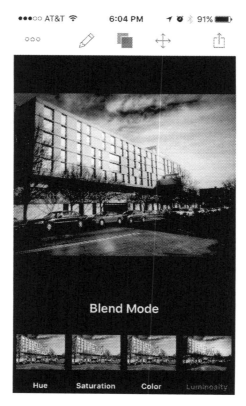

Figure 6-24. Switching our Blend Mode to Luminosity in Image Blender

7. Finally, we want to slide our Luminosity adjusted composition to the right until about 70% (Figure 6-25).

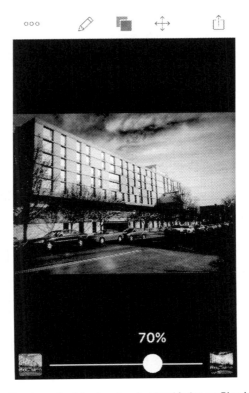

Figure 6-25. Adjusting the strength of the Luminosity blend in Image Blender to 70%

8. Tap the share button on the top right. Then tap Save to Camera Roll.

9. This final step creates our third "app-stacked" layered image, which we will import into the Mextures App for final adjustments.

MEXTURES STEPS:

1. In our final app, we will apply some subtle lighting and textures to our image to give it a more artistic, film effect. To accomplish this task, we need to employ the power of the Mextures App, which we detailed in Chapter 5. You can find Mextures in the App store at `https://itunes.apple.com/us/app/mextures/id650415564?mt=8`

2. Once you have installed Mextures, open it.

3. Tap on the Library button and locate the final Image from the previous Image Blender Exercise and load it into Mextures.

4. Tap Don't Crop to maintain the full aspect ratio.

5. Tap the Radiance Textures and swipe right until you find the Nebula Texture. Tap it to select it. Now, tap the image to bring up the slider to adjust the effect's strength. Move the slider to about 70 (Figure 6-26).

Figure 6-26. Applying the Nebula Texture under the Radiance textures in the Mextures App

6. Now, tap the '+' button to add another layer and tap Grit and Grain textures.

7. With your finger, swipe to the right until you find the Copper Plated texture. Tap it to apply. Tap the image to bring up the slider to adjust the effect's strength. Set it at about 25 (Figure 6-27).

Figure 6-27. Applying the Copper Plated Texture under the Grit and Grain textures in the Mextures App

8. Tap the export button in the top right, and tap Save to Photo Library to save your final image to your device (Figure 6-28).

Figure 6-28. The final layered (App-Stacked) image

TOUCH EXPERIMENT 3: PAINTERLY APPROACH

There are many creative apps that allow you to draw and paint over your image, or even create a custom image from scratch. These apps go beyond the simple technique of filter processing as in the early days of iPhoneography. With these types of artistic apps, you have the ability to subtly enhance your iPhone photos in very unique ways.

For this exercise, we will use an app called Repix – Inspiring Photo Editor, which you can find in the app store at http://sumoing.com/apps/repix Repix is initially free, but you can add in-app purchases that include artistic brushes, textures, filters, etc. For this exercise, I will be using some of the add-on packs found in the Master Collection. If you don't want to purchase these extra add-ons, no problem, just follow along with the exercise below.

ANDROID USERS: Repix is also available on the Google Play Store!

1. To begin this tutorial, locate the Still Life image in your resources folder which is at `http://www.yaddayaddayadda/resources/touch_experiments?etc`. You will need to add the image I have provided to your iPhone's camera roll with the method I explained earlier. Or, you can use another image of your choice.

2. Once you have installed Repix, open it.

3. Tap the menu icon on the top left and locate the image, then tap it to open it in Repix.

4. Swipe your finger to the left to locate the Blurrer tool and brush on the screen with your finger to blur the background of the image (Figure 6-29).

Figure 6-29. *Blurring the background with the Blurrer tool in Repix*

5. Tap the Filters button on the bottom left of the menu and locate Stark. Tap to apply the filter to the image and swipe your finger to the left to adjust the strength to about 80% (Figure 6-30).

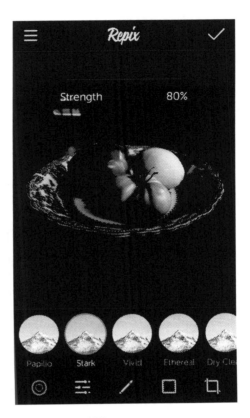

Figure 6-30. Applying the Stark filter at 80%

6. The next goal is to apply a texture around our still life subject using the Hatching tool. Tap the Brush tool icon in the bottom center of the menu and swipe your finger to the left until you find the Hatching tool. Tap to select it, and begin painting around the background of your subject. You can adjust the precision of the Hatching tool by simply pinching two fingers and zooming in on you image. The more you zoom your image, the more precise the tool becomes (Figure 6-31).

Figure 6-31. Zooming into our image with the Hatching tool for a more precise edit

7. At this point, allow your creative freedom to take hold and add the
 hatching effect around the background of your image as you wish. If
 you make a mistake, and accidentally add the effect to your subject,
 click the Undo button (the left arrow button) on the top left to go back
 in history and undo your edit. Additionally, you can also select the
 Undoer brush and simply brush over your mistake to undo the effect
 (Figure 6-32).

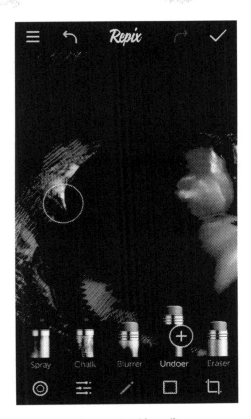

Figure 6-32. Applying the Undoer brush to our hatching edit

8. For a finishing touch, we will add the Spray effect to our subject. Swipe the bottom brush menu and locate the Spray brush. Tap it and begin to lightly paint with your finger over the subject (Figure 6-33). Again, if you make a mistake, you can use the Undoer brush to undo the effects of the Spray brush.

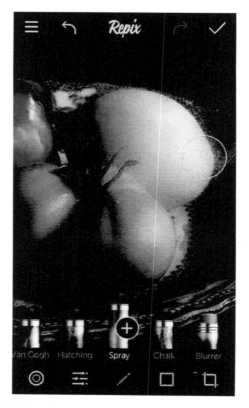

Figure 6-33. Applying the Spray brush to our still life subject

9. Tap the Check button on the top right to save your final edit (Figure 6-34).

Figure 6-34. The Repix edited image

WALKABOUTS

Sometimes, we need to disconnect from our busy lifestyle, unwind and detach, to reconnect with our self. Early Australian aborigines practiced what they called a "walkabout," which was a rite of passage for their male youth to essentially "soul search" for their purpose while living in the wild for months at time. As a journey, walkabouts were often very spiritual and life changing for the participants. In the modern era, a walkabout simply refers to a walking journey; one that can be performed solo or in a group. Photography groups often form for the purpose of capturing themes through a series of walks called photo walks. Just getting out and seeing the world around you is key to discovering, interpreting and relaying your vision. Walkabouts, whether solo or in groups, can help you expand your perception (Figure 6-35).

Figure 6-35. A walkabout at Lake Superior Provincial Park, Ontario. Shot with my iPhone 4s. Edited with Mextures and Lens Light

I am fortunate enough to live in a forested area where I often spend time just exploring nature. But, you can explore the world around you no matter where you live. The goal here is to just grab your smartphone and head somewhere. Anywhere. You can point yourself in a predetermined direction, or simply find a new place to discover just by chance. Perhaps you live in the city but have never ventured to a particular building, park, or tourist landmark. Make notes as you travel, whether mentally or physically in a journal, and ask yourself, "how does this journey make me feel? Have I discovered anything different?" Now, begin to document your "walkabout" with your iPhone. Apply many of the principles you have learned early in this book, or explore new ideas on your own. Your goal here is to just let go, search your soul, listen, see, and think. Sometimes we spend too much time doubting our abilities before we even try to discover them.

MISTAKES ARE GIFTS

When we fail, we learn from our failure. Though others may see it as a mistake, it is important to know it is really a gift, since it leads to a path of creative understanding. If you complete some of the exercises in this chapter, yet fail to make your final image look exactly like the one I have provided, by definition, that is a failure. But, you should never look at it that way; because as you work through an exercise, you may discover something I missed. Or, you might find another way to achieve a similar goal. The point here is to be open to failure, which is part of the creative process. For what is failure really but the pathway to success? Ralph Waldo Emerson said, "The greatest glory in living lies not in never falling, but in rising every time we fall." As creative iPhoneographers, we must strive to keep rising and learn from our mistakes (Figure 6-36).

Figure 6-36. Phonenix Falling Into Birth. Sometimes, mistakes are unexpected gifts. In this example from a composition I created, the clouds parting above the tree line, bottom center, create the "unintended" illusion of a bird in flames, rising from the fire and ash. Shot with my iPhone 5s. Processed in Snapseed and Mextures

Within our journey, as we discover who we are as photographers and artists, we must share our knowledge along the way. In the next chapter, I'll detail just how to achieve this goal by connecting with the community through various photo sharing and social platforms.

ART GALLERY

When we seek to discover the best in others,
we somehow bring out the best in ourselves.

- Ralph Waldo Emerson

Connecting With the Community

Review and Recommendations on Popular Photo Sharing Services and Networks

Art can be experienced and shared. It helps us understand the connection we share with each other. Since art can reach beyond the verbal, and communicate in non-verbal ways like no other medium, art can take us to emotional states of bliss, pain, joy, angst, and sadness. It can reward us with its beauty–its honesty. Art can talk to some; yet, be silent to others. When we share what we have created, we open ourselves up to honesty in hopes that others might see our creation in its pure form. Sharing gives us feedback, whether good or bad; it leads us to understand who we are as a creator, and is an essential part of the creative process.

With iPhoneography and mobileography, we are inherently connected to each other because, by design, our devices are connected to a network engineered for rapid communication. Thus, sharing is a natural step in the process that opens the door to feedback, dialog, and learning – a door that will further us along our creative path.

In this chapter, we will discuss some of the popular sharing services currently available, where you can upload, title, tag, and describe your work. Keep in mind that participation in the dialog is important, and highly recommended, but certainly, not required.

Instagram

One of my favorite photo-sharing (and video-sharing) services is Instagram. Conceived in by Kevin Systrom and Mike Krieger, Instagram, launched in October 2010, boasts 200 million users as of this writing. Fusing the words, "instant camera," and "telegram" Systrom and Krieger created the concept of Instagram, which debuted as a simple image sharing interface equipped with instamatic-like filters that could be easily applied to a captured image (Figure 7-1). The built-in social sharing with easy filter application popularized the app shortly after its debut. Instagram is like a streamlined version of Facebook, and a visual Twitter. The user interface consists of a stream where you can post images along with a caption or description. Other users, who follow you, can tap the "heart" icon to "like" your image, and/or make comments in your image's thread.

Figure 7-1. Instagram includes 24 Filters to enhance your photo

When Instagram debuted, it was limited to only square format uploads. With the release of Instagram version 7.5 in August of 2015, users are no longer limited to posting only square format images. However, many users still prefer the traditional square format. Additionally, like Twitter and Facebook, Instagram features hashtags, which serve as a way to categorize and connect images together across the entire app's user base. So, for example, you could add a hashtag to a word in your caption, or a comment, which would add your image to the related category of the hashtag (See Figure 7-2). Other features include the ability to tag people in your posts (like Facebook), adding your photo to a map via its geo metadata, and advanced image editing features in addition to the standard filters (See Figure 7-3).

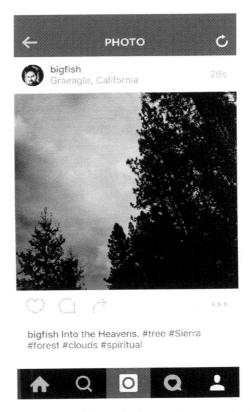

Figure 7-2. With Instagram, you can add a caption to your photo, as well as hashtags, which begin with a '#', that help you categorize and mark your images by related subject areas. You can also geotag your image

Figure 7-3. Instagram features advanced editing beyond the basic presets

In April, 2012, Instagram was acquired by Facebook for 1 billion dollars. At first, the acquisition was seen as a very negative thing to the Instagram community; since unlike Facebook, Instagram was free of commercialization, and the community was worried Facebook would turn the platform into a commercial zone. However, to date, Facebook has done little to change the original Instagram experience. Ironically, Instagram has naturally evolved into a strong, yet subtle marketing platform for brands, artists and related products.

One of the key concepts of Instagram is in its "behind the scenes" focus with things as simple as "what I'm eating now" or, "what my self (selfie) looks like now," to, "what the weather looks like now," or, "what's happening backstage at the Madonna concert," for example. The act of instantly reporting what's happening via a photo or short video is what continues to make Instagram popular to this day.

Instagram is a superb platform for sharing your body of work, and it offers a well-connected community. The app supports a "post once—share many" concept in that you can make a single post to your Instagram feed and

share it to other popular social media services like Facebook, Twitter, Tumblr and Flickr (See Figure 7-4). You can share to your followers or privately (directly) to anyone who follows you. This is another reason why I find the app so appealing for sharing my iPhoneography–speed and simplicity.

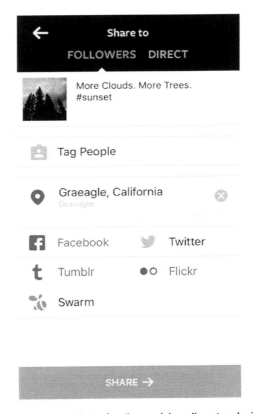

Figure 7-4. Sharing your Instagram photos in other social media networks is quick and easy

Flickr

Another great photo sharing service is Flickr. In fact, Flickr is one of the oldest photo sharing services, founded in February 2004. Prior to the introduction of the iPhone in 2007, DSLR photographers, who wanted to showcase their work, made Flickr popular. The service allows users to categorize their images with tags (much like hashtags), and further organize photos in albums and galleries. So, for example, you can upload a series of hi-resolution photos to Flickr and create an album to showcase your work. From there, you could create a gallery of multiple albums to showcase a specific theme or subject. In addition, Flickr offers licensing attributes where you can designate how you want your photo to be licensed–all rights reserved, share alike, creative

commons, no derivatives, non-commercial, non-commercial share alike, or non-commercial no derivatives. Like EyeEm, Instagram, Pinterest, Twitter and Tumblr, Flickr features followers (friends) who you can designate in subgroups of friends or family. Flickr allows you to streamline sharing further. For example, you can configure an album, gallery or photo to be available only to the public, or private, or you can set up the sharing to be only available to your friends or family. Finally, Flickr features Groups (See Figure 7-5), which is another way you can interact with other Flickr users on subjects of similar interests. With groups, you can add photos that you have uploaded and tag them to that specific group. Additional tools in Flickr include advanced social sharing through Facebook, Twitter and Tumblr, slideshows, and blog embedding. The Flickr mobile app also features cropping and editing tools, including one-touch filters similar to Instagram, where you can enhance your mobile photos prior to upload (Figure 7-6). You can also "round-trip" edit photos after you've uploaded them with the built-in editor, Adobe Aviary, and have your edits applied simultaneously across all your devices.

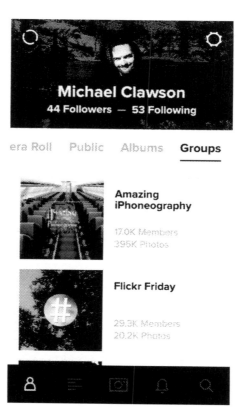

Figure 7-5. Flickr groups allow you to share your work with special interest groups geared toward a central theme

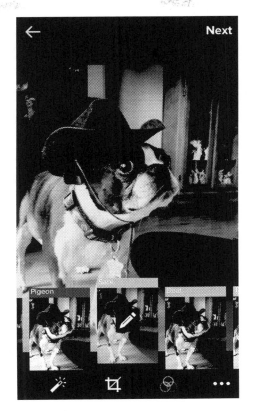

Figure 7-6. The Flickr mobile app includes one-touch filters similar to Instagram for quick editing of your photos prior to upload

Tumblr

Tumblr is a microblogging service that was launched in 2006 by David Karp, and later acquired by Yahoo in May of 2013. As a photo sharing social media platform, Tumblr can be a handy way to share your creations (See Figure 7-7) since the platform is designed as a microblogging service similar to Twitter, where you can post your work along with comments and geo data. One of the cool features of Tumblr is customization. With the system, you can customize your Tumblr website with either a built-in template, or custom edit the HTML and CSS code to create a unique look and feel. Tumblr also allows other users to "re-blog" your content, which has incurred some critique from the community since this can technically violate your copyright. Another negative of the Tumblr is it tends to have a large amount of adult content, which is not regulated. So, in general, Tumblr as a platform might not be ideal for youth.

Michael Clawson

Swimming up the stream of digital
chaos & bliss. Chief Fish of Big Fish
Creations, an advertising and digital
media company in the Sierra town of
Graeagle. www.bigfishcreations.com

Figure 7-7. Tumblr is a microblogging site that is perfect for photo sharing

500px

As a professional photo-sharing platform, 500px (pronounced five hundred pixels) is a community and platform similar to Flickr, but with a much more modern interface and feature set (See Figure 7-8). Founded in 2009 by Oleg Gutsol and Evgeny Tchebotarev, the Toronto based service offers a beautiful user interface in both their desktop and mobile platforms. Similar to Flickr, users can upload photos to their stream and create sets, which can also be added to portfolios. In addition, 500px features groups, where users can join and follow subjects of interest. Users can also interact with your posts through comments and likes, which 500px tabulates in a ratings system they refer to as "Pulse." Additional features include the ability to sell your works through an online store, and purchase royalty-free works via their 500 Prime service. Like Tumblr, 500px tends to have a large amount of adult content. However, warnings are given before viewing adult content, and accounts can be configured to block adult content. Users are asked to mark adult content, and 500px staff regularly monitors the site to make sure content is marked accurately.

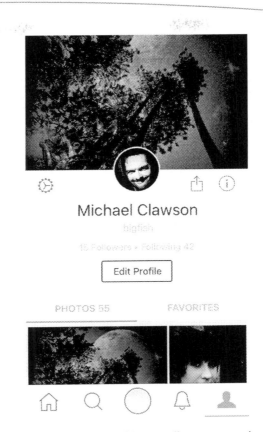

Figure 7-8. 500px offers similar features to Flickr; yet, offers a more modern interface

Facebook

Mark Zuckerberg and his college roommates first conceived Facebook as "thefacebook," in February of 2004. Today, Facebook is the largest social network with an estimated 1.44 billion active users as of this writing. As a photo-sharing network, Facebook has numerous features aimed squarely at image sharing. Like other popular photo sharing platforms, Facebook supports desktop and mobile devices with an intuitive user interface and advanced sharing options. Facebook's approach to image sharing is similar to Flickr's and 500px, in that you can create albums to organize your photos by subject or theme (See Figure 7-9). You can configure the privacy of any photo to be viewable by just your friends, the public, your lists, just you, or a customized list. Each photo has a comments thread attached to it where anyone with proper access can make comments about your photo. In addition, Facebook's mobile app includes basic one-touch filters that allow you to add quick effects to your image before upload (See Figure 7-10). You can also tag people or pages with the tag button. This is handy for describing exactly who or what is in your photo.

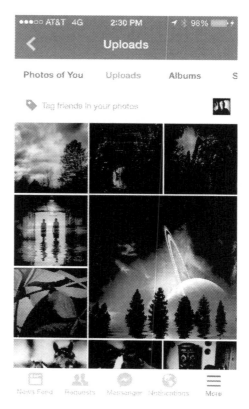

Figure 7-9. With Facebook, you can organize photos with albums and add tags to further describe your image

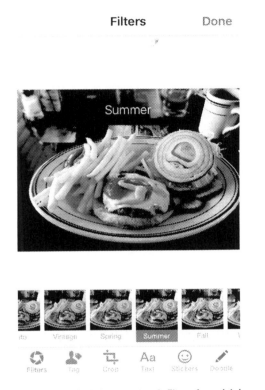

Figure 7-10. Facebook's mobile app includes one-touch filters for quick image editing

In addition to personal and business accounts, Facebook allows you to create Pages (See Figure 7-11) and Groups. The advantage here is you can manage a business page focused on your images, and make it available to the public for showcasing your work without having to compromise the privacy of your personal account. Groups operate in a similar way, but have additional security to allow access only to approved members. For both the Pages and Groups options, when you create a new page or group, you are added as an admin, and your page or group is linked to your personal account. You can add additional admins or users to help manage the page or group, which is a great tool to promote your mobile photography. It also enables you to readily scale your business.

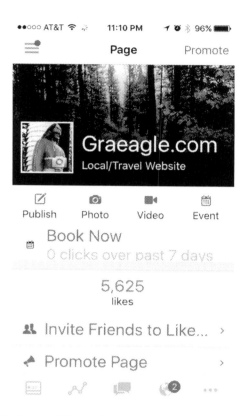

Figure 7-11. Facebook's Pages and Groups features allow you to create specific areas of interest

Twitter

Twitter is a microblogging platform first created by Jack Dorsey, Evan Williams, Biz Stone, and Noah Glass in 2006. When the platform was first introduced, it was largely an online text messaging system that limited a posts count to 140 characters. What made Twitter popular was its real-time approach to social sharing. Users could post quick messages to their followers and get instant replies via "@" messages. But, as a largely text-only medium, it was limited as a photo sharing service until Twitter opened up their API and allowed other third party services to access certain aspects of the service. So, for example, users could post a quick Tweet

and attach a photo, which was actually handled by another photo-sharing service like TwitPic or Flickr. However, recently, Twitter has added their own photo-sharing service integrated into the platform that allows users similar functions to Instagram, which include one-touch filters, geo tagging, and user tagging to name a few. With over 274 million active users as of this writing, Twitter is an effective way to share your imagery with the public.

Behance

Scott Belsky co-founded Behance in 2006 as a network to help creatives promote their work. In 2012, Adobe acquired Behance and integrated it within their Creative Cloud Services. As a portfolio sharing platform, Behance is an excellent service to highlight your smartphone photography (See Figure 7-12). With Behance, you are able to upload your work along with detailed descriptions, simple titles, or simply as is. One of the cool features of the platform is you are not limited to simply uploading finished projects, but, you have the ability to upload works in progress (WIP). So, for example, you could upload a photographic study that you might be undergoing, and thus detail your journey along the way. Like Twitter and Instagram, Behance allows you to follow others, and have followers, and it also keeps track of your project views and appreciations, which is a handy metric of your overall impact (See Figure 7-13). Behance also offers a Teams feature, which allows you to share related work from a company or coworkers. You can also use tags to identify your work with specific subjects, and include the applications you used to create your work. Like Flickr, Behance allows you to set your copyright level for public sharing. Finally, you can share you projects or works in progress via Facebook, Twitter, LinkedIn and Pinterest. Behance is available for iOS or Android platforms.

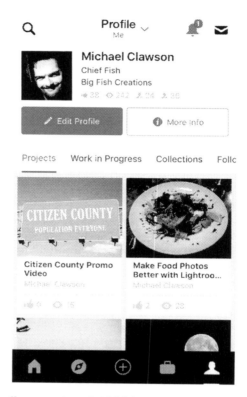

Figure 7-12. Behance offers a great way to highlight your smartphone photography works-in-progress or final compositions

Close **Michael Clawson** ⬆️

STATS

👁 PROJECT VIEWS 242
📢 APPRECIATIONS 38

CONNECTIONS

👤 FOLLOWERS 24
👥 FOLLOWING 36

FOCUS

Photography, Digital Photography, Visual Effects

ON THE WEB

🟦 🔵 🔵 🔵 🔵 🔵

ABOUT

Swimming up the stream of digital chaos and
bliss. Chief Fish of Big Fish Creations, an
advertising and digital media company in the
Sierra town of Graeagle, California.

Figure 7-13. Behance keeps track of your project views and appreciations, which is a handy metric of your overall impact

EyeEm

Founded in January of 2010 by Florian Meissner, EyeEm was developed as a professional photography platform for mobile photographers. Similar to Instagram, EyeEm offers 24 filters (see Figure 7-14), and 12 editing modules (see Figure 7-15) that allow you to refine and enhance your mobile photos. Available for both iOS and Android, EyeEm is a solid photo sharing platform for mobile photography.

Figure 7-14. EyeEm features 24 film filters to enhance your photos

Figure 7-15. There are 12 editing modules in EyeEm that allow you to further enrich your photos

Pinterest

Pinterest was developed in 2009 by Ben Silbermann, Paul Sciarra and Evan Sharp, and soon launched in beta format in March of 2010. The concept of the service is to allow registered users to link (pin) anything they come across on the web, whether experienced via mobile or on the desktop. Pinned items are typically added to Pinterest "boards" (See Figure 7-16). Of course, Pinterest has faced controversy regarding infringement from users sharing copyrighted works. They have tried to address these issues by creating things like a "nopin" meta tag for webmasters, and automatic attribution for images pinned from Flickr, Behance, YouTube and Vimeo. Still, the service is very popular, and is used by photographers to share their work.

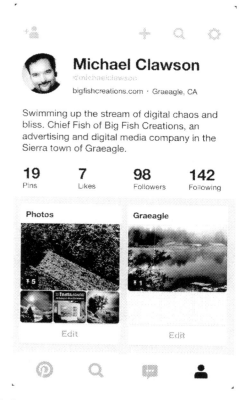

Figure 7-16. Pinterest allows you to organize your "pins" on boards

iCloud

Apple's iCloud Photo Stream and iCloud Photo Library are built-in features to Apple's iOS software. The service automatically synchronizes (uploads) your photo library from all of your devices, and can be configured to even handle video uploads. With iCloud, you have the ability to access your photos from any device. Edits can be made via your mobile device, or desktop computer. You also have the ability to share your photos via iCloud Photo Sharing, Facebook, Flickr, or Twitter (See Figure 7-17).

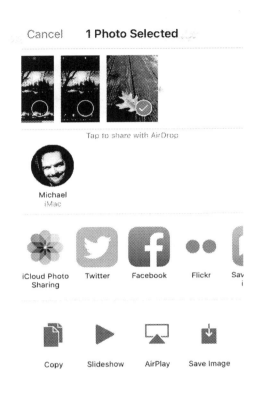

Figure 7-17. Sharing in iCloud is built-in to both desktop and mobile devices

Google Photos

As the new photo service on the block, Google Photos is an up-and-coming photo archiving and sharing service. Prior to its inception, Google Photos was the successor to Google+ photos. Google can be configured to automatically backup your photos from your smartphone, desktop computer or storage card. Like iCloud, this makes it easy to access your photos from whatever device you prefer. Like Flickr and Lightroom, Google Photos allows you to re-edit your photos once they have been uploaded (See Figure 7-18), as well as create collections to group your shots for specific subject matter. The service is available both for Android and iOS devices.

Figure 7-18. Editing a photo with Google Photos

Adobe Lightroom Mobile

In 2007, Adobe Lightroom was launched as a photo processor and image organizer for the Mac and Microsoft Windows. As a powerful image editor, one of Lightroom's strengths was its ability to work in RAW, non-destructive format. In April 2014, Adobe launched Lightroom Mobile for iOS, and Android devices. While the app didn't include the full feature set of the desktop version of Lightroom, it offered many usable editing features that utilized a non-destructive editing workflow (Figure 7-19). Like Flickr, Lightroom offers a round-trip non-destructive editing workflow no matter which device you edit with. In addition, you can share your edits with many social media sharing networks like Flickr, Twitter, Facebook, iCloud, etc., as well as Lightroom's own social sharing network.

Figure 7-19. Lightroom Mobile edits on iPad

Where We Are Now

Throughout the journey in this book, you've learned where digital photography began, and how it has evolved into another art form known as iPhoneography and mobileography. Though this book largely focused on the iPhone and related devices, the reality is that the transition from desktop to mobile continues on many platforms. As a result, creativity has changed, making itself available to a larger group of users. The way we create with touch in the mobile world makes us feel less constrained, and intimate with our creation. Connectivity and simplicity is the driving force now recognized by many of the major players in technology such as Apple, Adobe, Microsoft and Samsung. Auto-synchronization via "the cloud," is the new battle cry for most of the tech made available today. No longer do we have to struggle with the methods of "technical" input before we begin to create—since things now just magically "appear" across all our devices in an instant. As a result, our creativity is left to expand outward, unfettered by the chains of technical hurdles. Here, we are left to see, dream, believe and create.

Appendix

Appendix A

In this section, I've listed my additional recommended apps and resources for iPhoneography. In the apps section, I've categorized the list in a fashion similar to Chapters 4 and 5, featuring shooting, editing, special effects, and sharing apps. In the community section, I've included links to online communities and websites focusing on iPhoneography and mobileography. Many of the apps listed below are compatible with both iPhone and iPad devices, and in some cases available on other platforms such as Android and the Windows Phone.

Shooting Apps

APP NAME	DESCRIPTION	DEVELOPER	iOS	Android
645 PRO Mk III	Advanced shooting app - high res saving. Filters.	Michael Hardaker	http://jag.gr/645pro/	
6x6	Vintage square shooting app.	Michael Hardaker	http://jag.gr/6x6/	
6x7	Vintage medium format shooting app.	Michael Hardaker	http://jag.gr/6x7/	
AutoBracket	Auto-bracketing shooting app. HDR.	Pictional LLC	https://itunes.apple.com/us/app/autobracket/id923626339?mt=8	
Average Camera Pro	Low light, low noise, long exposure camera.	Dominik Seibold	https://itunes.apple.com/us/app/average-camera-pro/id415577873?mt=8	
Burst Mode	High speed camera app. Burst mode.	Cogitap Software	http://itunes.apple.com/us/app/burst-mode-high-speed-camera/id393131664?mt=8	
Camera	Advanced photo and video camera.	Apple	Included with OS	
Camera Awesome	Advanced shooting and editing app.	SmugMug	http://www.cameraawesome.com	http://www.cameraawesome.com
Camera Plus	Advanced shooting and editing app.	Global Delight Technologies Pvt. Ltd	http://www.globaldelight.com/iphone/cameraplus/	
Camera+	Advanced shooting and editing app.	tap tap tap, LLC	http://campl.us	

Name	Description	Company	URL
CamMe	Selfie shooting app.	PointGrab	http://www.pointgrab.com/camme/
Camu	Shooting and editing app.	Sumoing Ltd	http://sumoing.com
Contrast by hornbeck	High contrast black & white shooting app.	Bubblesort Laboratories LLC	https://itunes.apple.com/us/app/contrast-by-hornbeck/id796171444?mt=8
Cortex Cam	Noiseless, low-light camera. Takes multiple images and merges to hi-resolution capture.	Whimsical Productions	http://www.cortexcamera.com
Fast Camera	Rapid speed. Burst mode. Timelapse. Video sharing.	i4software	http://www.i4fastcamera.com http://www.i4fastcamera.com
Fotor HDR	MultiStyle HDR Camera.	Chengdu Everimaging Science and Technology Co., Ltd	http://www.fotor.com http://www.fotor.com
HDR	Fast HDR shooting with filters.	Lucky Clan	http://luckyclan.com/hdr/
Hipstamatic	Creative filter shooting app. Square format.	Hipstamatic, Inc.	http://hipstamatic.com
Lenka	Dedicated black & white shooting app.	Kevin Abosch	https://itunes.apple.com/us/app/lenka/id887039379?mt=8 https://play.google.com/store/apps/details?id=com.lenka

(continued)

APP NAME	DESCRIPTION	DEVELOPER	iOS	Android
LongExpo Pro	Slow shutter, long exposure app.	EyeTap Soft	http://eyetapsoft.com/longexpo-app.html	
MagiCam	Filter shooting app.	tap tap tap, LLC	http://magicam.photos	
Manual	Manual shooting app.	Little Pixels	http://shootmanual.co	
ManualCam	Manual shooting app.	34BigThings	http://34bigthings.com/project-type/applications/	
Manual Cam	Manual shooting app. Filters.	LOFOPI	http://lofopi.com	
Manual Photo Cam	Manual shooting app.	Rego Korosi	https://itunes.apple.com/us/app/manual-photo-camera/id931239268?mt=8	
MPro	Dedicated black & white shooting app.	Toshihiko Tambo	http://www.tambo.jp/mpro	
MultiCam	Multi-exposure, multi-focus app, Litro-like.	Lucky Clan	http://luckyclan.com	
Night Modes	Night shooting app - slow shutter.	Cogitap Software	https://itunes.apple.com/us/app/night-modes/id572215621?mt=8	
NightCap	Night shooting app - slow shutter.	Chris Wood	http://www.nightcapcamera.com	
NightCap Pro	Night shooting app - slow shutter.	Chris Wood	http://www.nightcapcamera.com	
Polamatic	Retro Polaroid-style shooting app.	Polaroid	http://www.polamatic.com	http://www.polamatic.com
Pro HDR X	HDR shooting app. Filters and adjustments.	eyeApps LLC	http://www.eyeapps.com	

App	Author/Company	Description	URL
ProCam	Samer Azzam	Advanced shooting and editing app.	http://www.procamapp.com
ProCamera 8	Cocologics	Advanced shooting and editing app.	http://www.procamera-app.com
Provoke Camera	Toshihiko Tambo	Dedicated black & white shooting app.	https://itunes.apple.com/us/app/provoke-camera/id840633665?mt=8
PureShot	Michael Hardaker	Advanced shooting app - high res saving.	http://jag.gr/pureshot/
Retrica	Sangwon Park	Filter shooting app.	http://retrica.co
Shoot	Samer Azzam	Manual shooting app.	http://www.procamapp.com
Slow Shutter Cam	Cogitap Software	Slow shutter, long exposure app.	https://itunes.apple.com/us/app/slow-shutter-cam/id357404131?mt=8
Slow Shutter!	Lucky Clan	Slow shutter, long exposure app.	http://luckyclan.com/slowshutter/
Top Camera	Lucky Clan	Advanced shooting and editing app.	http://luckyclan.com
trueHDR	Pictional LLC	Fast HDR shooting and editing.	http://www.pictional.com
vividHDR	Ittiam Systems (Pvt) Ltd	Superfast HDR shooting and editing app.	http://www.ittiam.com/vividhdr/
Warmlight - Manual Camera & Photo Editor	Apalon	Manual shooting app. Filters.	http://www.apalon.com/warmlight.html

Editing Apps

APP NAME	DESCRIPTION	DEVELOPER	iOS	Android
Adobe Lightroom	Lightroom mobile app. Non-destructive editing. Integrated with Adobe Creative Cloud.	Adobe	https://itunes.apple.com/us/app/adobe-lightroom/id804177739?mt=8	https://play.google.com/store/apps/details?id=com.adobe.lrmobile
Adobe Photoshop Express	High quality editing filters. Excellent noise reduction filter.	Adobe	https://itunes.apple.com/us/app/adobe-photoshop-express/id331975235?mt=8	https://play.google.com/store/apps/details?id=com.adobe.psmobile
Adobe Photoshop Mix	Image/Layer compositing app with masking.	Adobe	https://itunes.apple.com/us/app/adobe-photoshop-mix/id885271158?mt=8	https://play.google.com/store/apps/details?id=com.adobe.photoshopmix
Adobe Photoshop Fix	Image retouching and restoration.	Adobe	https://itunes.apple.com/us/app/adobe-photoshop-fix-retouch/id1033713849?mt=8	
Afterlight	Advanced editing and filters.	Afterlight Collective, Inc	http://afterlight.us	http://afterlight.us
Analog Film	Analog film filters.	ordinaryFactory	http://analogfilmapp.com	
Aviary	Powerful photo editor.	Aviary (Adobe)	https://itunes.apple.com/us/app/photo-editor-by-aviary/id527445936?mt=8	https://play.google.com/store/apps/details?id=com.aviary.android.feather
Big Photo	Resizes image.Cropping and Batch Resize features.	Zynsoft Inc.	https://itunes.apple.com/us/app/big-photo/id513663883?mt=8	

Name	Description	Company	URL
CameraBag 2	Film quality filters and adjustments.	Nevercenter Ltd. Co.	http://nevercenter.com/camerabag/mobile/
Color Time 2	Color grade editor for photos and video.	Photographica Limited	http://www.photographica.co.uk
Dramatic Black & White	Black & White editing app.	JixiPix Software	http://jixipix.com
Dynamic Light	Simulated HDR Editing effects app.	Mediachance	https://itunes.apple.com/us/app/dynamic-light/id422494924?mt=8
Enlight	Fully advanced editing and special effects app	Lightricks Ltd.	http://www.enlightapp.com
Facetune	Powerful portrait editing app.	Lightricks Ltd.	http://www.facetuneapp.com
Filterstorm Neue	Powerful editing app with layers. High resolution export.	Tai Shimizu	http://filterstormneue.com
Formulas	Custom, multilayered photo effects	Samer Azzam	http://www.procamapp.com
Fotograf	Photo editing app, plus filters.	Nevercenter Ltd. Co.	http://www.nevercenter.com/fotograf/
FX Photo Studio	Photo editor, filters, effects, camera, plus frames.	MacPhun LLC	https://itunes.apple.com/us/app/fx-photo-studio-photo-editor/id312506856?mt=8

(continued)

APP NAME	DESCRIPTION	DEVELOPER	iOS	Android
Handy Photo	Mobile photo editing suite (color correction, content-aware retouch, edit and cut out, filters, textures and more)	Adva-Soft	http://adva-soft.com/products/handy-photo/	http://adva-soft.com/products/handy-photo/
Image Blender	Simple, yet powerful layer blending with masking.	Johan Andersson	http://jhnd.me/imageblender/	
Instaflash	Transforms dark shots into vibrant photos.	Anlei Technology Inc.	http://www.instaflash.com	
Instagram	Photo sharing and editing app.	Instagram, Inc	https://itunes.apple.com/us/app/instagram/id389801252?mt=8	https://play.google.com/store/apps/details?id=com.instagram.android
Laminar Pro	Photo editor with advanced editing.	Pranav Kapoor	http://ventessa.com	
Leonardo	Photo Editor with Layer, Selection and Masking.	Pankaj Goswami	http://www.leonardoapp.com	
Litely	Photo editing app, film filters.	Litely LLC	http://lite.ly	
Lucid	Automatic image correction "perfection" app. With adjustments.	Athentech Imaging	http://www.athentech.com	

Mobile HDR	Merges three exposures to HDR.	Intellsys s.r.l.	https://itunes.apple.com/us/app/mobile-hdr/id473200715?mt=8
Modern Editor	Filters, textures, text overlay and editing.	Jeffrey Sun	http://jsun.us/moderneditor/
Noise Master	Noise removal and sharpening.	Lucky Clan	http://luckyclan.com/noisemaster/
Perfectly Clear	Automatic image correction "perfection" app. With adjustments.	Athentech Imaging	http://www.athentech.com
Photo FX	Extensive set of filters and masking.	The Tiffen Company	http://software.tiffen.com/products/iphone-ipad-apps/photo-fx
Photo Mage	Filters. Editing. Text overlay.	Roman Efimov	https://itunes.apple.com/us/app/photo-mage/id566318917?mt=8
Photogene 4	High quality photo editor plus effects. Resizing and hi-res export.	Omer Shoor	https://itunes.apple.com/us/app/photogene-4/id363448251?mt=8
Photos	Advanced editing and filters. Non-destructive editing.	Apple	Standard with iOS
PhotoToaster	Photo editing with filters. Editing brushes.	East Coast Pixels, Inc.	http://www.eastcoastpixels.com/

(continued)

APP NAME	DESCRIPTION	DEVELOPER	iOS	Android
PhotoWizard	Wide range of filters, textures, light leaks and masking.	Pankaj Goswami	http://beltola.com	
Picfx	Film quality filters plus layers.	ActiveDevelopment	http://picfx.co	
PixlrExpress	Photo editor with combination effects & overlays.	Autodesk Inc.	https://pixlr.com	https://pixlr.com
Relight	HDR Editing App	Code Organa LLC	http://codeorgana.com	
Relook	Portrait editing app.	Sumoing Ltd	http://sumoing.com/apps/repix	http://sumoing.com/apps/repix
Rookie	Advanced filter packs, textures, light leaks, stickers, and text overlay effects.	JellyBus Inc.	http://www.jellybus.com	
Simply B&W	Black & white conversion app.	James Moore	http://www.fotosyn.com	
Simply HDR	Simulated HDR editing effects app.	JixiPix Software	http://jixipix.com	
SKRWT	Lens correction and straightening editing app.	mjagielski	http://skrwt.com	

Snapseed	High quality photo editor plus effects.	Google, Inc.	https://itunes.apple.com/us/ app/snapseed/id439438619?mt=8	https://play.google.com/ store/apps/details?id=com. niksoftware.snapseed
SquareReady	Crops and adjusts image for square format.	FANG Inc	http://ios.fang.co.jp/ index_e.html	
Stackables	Layered textures and effects.	Samer Azzam	http://www.procamapp.com	
TiltShiftGen2	Tilt-shift editing app. Filters.	Art & Mobile	https://itunes.apple.com/ us/app/tiltshiftgen2/ id706765970?mt=8	
TouchRetouch	Photo retouching app. Removes objects, spots, etc., from image.	Adva-Soft	http://adva-soft.com/ products/touch-retouch/	http://adva-soft.com/ products/touch-retouch/
TrueFilm	Film quality filters and adjustments.	Marvin Lee	http://truefilm.co	
Vintique	Vintage filters and powerful image editing tools.	GMY Studio	http://gmystudio.co	

Special Effects Apps

APP NAME	DESCRIPTION	DEVELOPER	iOS	Android
Adobe Capture	Create brushes that can be applied to Photoshop, Illustrator or Adobe Sketch. Integrated with Adobe Creative Cloud.	Adobe	http://www.adobe.com/products/capture.html	http://www.adobe.com/products/capture.html
AfterFocus	DSLR depth of field effects.	MotionOne.co.Ltd	http://appm1.com/afterfocus/	http://appm1.com/afterfocus/
Alien Sky	Overlay masked sky objects and effects. Layers.	BrainFeverMedia	http://www.brainfevermedia.com	
Aquarella	Generates watercolor-style painted image.	JixiPix Software	http://jixipix.com	
Artomaton	Autopainting app. "Artificial Intelligence Artist."	futurala	http://itunes.apple.com/us/app/artomaton-the-ai-painter/id718222634?mt=8	
ArtStudio	Painting and editing app. Layers.	Lucky Clan	http://www.luckyclan.com	
Big Lens	DSLR depth of field effects.	Reallusion Inc.	http://app.reallusion.com	http://app.reallusion.com
Brush Strokes	Transforms photos to brush stroke style painting.	Code Organa LLC	http://codeorgana.com	

App	Description	Company	URL
Circular	Tiny Planet effects. Overlay masked objects and effects. Layers.	BrainFeverMedia	http://www.brainfevermedia.com
Color Effects	Colorizing, overlay and painting app.	The Othernet, LLC	https://itunes.apple.com/us/app/color-effects-splash-sketch/id409913910?mt=8
Color Lake	Adds water anywhere on photo.	Ababeel	https://itunes.apple.com/us/app/color-lake-live-video-from/id492501888?mt=8
Color Splash	Colorizing app. Paint over black & white.	Pocket Pixels Inc.	http://www.pocketpixels.com/
Color Thief	Transfers color from one photo to the next.	Yellow Cedar Software, Inc.	https://itunes.apple.com/us/app/color-thief/id580674843?mt=8
Cycloramic for iPhone 5/5S	Panorama app. Unique hands-free panorama mode.	Egos Ventures	http://cycloramic.com
Cycloramic for iPhone 6	Panorama app. Unique hands-free panorama mode.	Egos Ventures	http://cycloramic.com
Diana Photo	Double exposure app.	Stettiner Games & More	http://dianaphotoapp.com
Diptic	Photo collage app.	Peak Systems	http://www.dipticapp.com

(continued)

APP NAME	DESCRIPTION	DEVELOPER	iOS	Android
DistressedFX	Grunge textures and editing.	We Are Here	http://www.distressedfx.com	
Elasticam	Stretch, squeeze, pinch to warp photos.	Lucky Clan	https://itunes.apple.com/us/app/elasticam-warp-melt-deform/id579803125?mt=8	
Faded	Image editing and adjustments. Film looks.	Vintage Noir	http://madewithfaded.com	
Fragment	Prismatic and fragment effects. Unique looks.	Pixite LLC	http://fragmentapp.com	http://fragmentapp.com
Glaze	Turns photos into paintings.	The 11ers	https://itunes.apple.com/us/app/glaze/id521573656?mt=8	
Grungestastic	Grunge effects app.	JixiPix Software	http://jixipix.com	
Hallows Eve	Creates spooky scenes with a library of Halloween things.	JixiPix Software	http://jixipix.com	
iColorama	Customizable, combination effects.	Enrique Garcia	https://itunes.apple.com/us/app/icolorama/id490528854?mt=8	
Inspire Pro	Painting, drawing and sketching app.	KiwiPixel	https://itunes.apple.com/us/app/inspire-pro-paint-draw-sketch/id354607982?mt=8	

InstaCollage Pro	Pic Frame & Photo Collage & Caption Editor for Instagram.	click2mobile	https://itunes.apple.com/us/app/instacollage-pro-pic-frame/id530957474?mt=8
Juxtaposer	Combines multiple pictures into photomontages.	Pocket Pixels Inc.	http://www.pocketpixels.com/
layrs	Multi-layer photo editing tool.	Artware, Inc.	https://itunes.apple.com/us/app/layrs/id630811124?mt=8
LensFlare	Lensflare effects. Layers.	BrainFeverMedia	http://www.brainfevermedia.com
LensFX	Overlay masked objects and effects. Layers.	BrainFeverMedia	http://www.brainfevermedia.com
LensLight	Lighting effects and bokeh. Layers.	BrainFeverMedia	http://www.brainfevermedia.com
LiveDOF	DSLR depth of field effects.	Emir Fithri Bin Samsuddin	https://itunes.apple.com/us/app/livedof-blur-tiltshift-animation/id423204960?mt=8
Living Planet	Create Tiny Planet videos.	Samer Azzam	http://www.procamapp.com
Lo-mob	Lo-mob brings lo-fi and photographic experimentations to your mobile pictures.	Aestesis LLC	https://itunes.apple.com/us/app/lo-mob/id334581568?mt=8

(continued)

APP NAME	DESCRIPTION	DEVELOPER	iOS	Android
Lo-Mob Superslides	Transforms pictures into slides or through-the-viewfinder images.	Aestesis LLC	https://itunes.apple.com/us/app/lo-mob-superslides/id634360290?mt=8	
Magic Hour	Instagram-like effects. Camera.	Kiwiple	http://magichour.me	http://magichour.me
Matter	Add 3D objects to photos.	Pixite LLC	http://matterapp.co	
Mextures	High quality textures, light leaks, grunge and film effects plus advanced editing and layers.	Merek Davis Com, LLC	https://itunes.apple.com/us/app/mextures/id650415564?mt=8	
Mobile Monet	Sketching and colorizing app.	East Coast Pixels, Inc.	http://www.eastcoastpixels.com	
Moku Hanga	Simulated Japanese wood-block printing,	JixiPix Software	http://jixipix.com	
Moldiv	Combine and edit multiple photos to make collages.	JellyBus Inc.	https://itunes.apple.com/us/app/moldiv-collage-photo-editor/id608188610?mt=8	
My Sketch	Pencil drawing effects app.	Miinu	https://itunes.apple.com/us/app/my-sketch-pencil-drawing/id448162988?mt=8	
Noir Photo	Black & white lighting and editing app.	Red Giant Software	https://itunes.apple.com/us/app/noir-photo/id429484353?mt=8	

Over	Overlays text over photos.	Over	https://itunes.apple.com/us/app/over/id535811906?mt=8
Phonto	Overlays text over photos.	youthhr	http://phontogra.ph
			http://phontogra.ph
Photo Frame Maker HD	Pic Collage + Border Styles, Caption Text Label, Filter Effect, Image Editor	Ki Tat Chung	https://itunes.apple.com/us/app/photo-frame-maker-hd-pic-collage/id475679369?mt=8
PhotoArtista - Oil	Turns photo into oil painting.	JixiPix Software	http://jixipix.com
PicBoost	Textures and filters.	ActiveDevelopment	https://itunes.apple.com/us/app/picboost/id446664420?mt=8
PicsPlay Pro	200 FX filters with masking.	JellyBus Inc.	https://itunes.apple.com/us/app/picsplay-pro/id527093371?mt=8
Portrait Painter	Generates portrait-style painted image.	JixiPix Software	http://jixipix.com
Rainy Daze	Rain and glow effects. Filter styles.	JixiPix Software	http://jixipix.com
Rays	Dramatic light ray effects app.	Digital Film Tools	https://itunes.apple.com/us/app/rays/id411190058?mt=8

(continued)

APP NAME	DESCRIPTION	DEVELOPER	iOS	Android
Reflect	Creative reflections (mirror) app. Overlay masked objects and effects. Layers.	BrainFeverMedia	http://www.brainfevermedia.com	
Reflex	Vintage still and video camera.	Lotogram	http://www.lotogram.com/reflex/	
Repix	Inspiring photo editor. Painting and effects.	Sumoing Ltd	http://sumoing.com/apps/repix	http://sumoing.com/apps/repix
RollWorld	Turns photos into circular compositions like Tiny Planets.	Li Wang	https://itunes.apple.com/us/app/rollworld/id867960225?mt=8	
Romantic Photo	Creates romantic mood & ambiance.	JixiPix Software	http://jixipix.com	
ScratchCam	Vintage and grunge app with one-touch filters.	Luna's Edge	https://itunes.apple.com/us/app/scratchcam-fx/id430226774?mt=8	
Shift	Create your own custom filters.	pixiteapps.com	http://pixiteapps.com	http://pixiteapps.com
ShockMyPic	Coherance enhancing shockfiltering.	Steinel, Gogolok GbR	https://itunes.apple.com/us/app/shockmypic/id442970062?mt=8	
Sparkmode (Mirrorgram)	Mirror effects.	Mirrorgram, Inc.	http://entersparkmode.com	
Split Pic	Collage photo editor & blender.	Easy Tiger Apps, LLC.	http://www.easytigerapps.com	http://www.easytigerapps.com

App	Description	Company	URL
Tadaa SLR	DSLR depth of field effects	menschmaschine Publishing GmbH	http://www.tadaa.net
Tangent	Shape and pattern overlays.	Pixite LLC	http://tangentapp.com
Tangled FX	Creates unique "tangled" art automatically from your images.	Orange Qube	http://www.orangeqube.com/tangledfx/
Tiny Planets	Turns photos into a sphere so that it looks like a tiny planet.	infoding.com	http://www.infoding.com/tiny-planet-photos/
TitleFx	Overlays text over photos.	East Coast Pixels, Inc.	http://www.eastcoastpixels.com
TinType	Creates daguerreotypes, tintypes, and other photographic processes from over a hundred years ago.	Hipstamatic, LLC	http://hipstamatic.com/tintype/
ToonCamera	Cartoon style video and camera app.	Code Organa LLC	http://codeorgana.com
Union	Masking and editing app for combining photos.	Pixite LLC	http://unionapp.co
Vintage Scene	Creates retro, old-style photos.	JixiPix Software	http://jixipix.com
Waterlogue	Turns photo into simulated watercolor style.	Tinrocket, LLC	http://www.waterlogueapp.com

Sharing Apps

APP NAME	DESCRIPTION	DEVELOPER	iOS	Android
500px	Mobile app for 500px.	500px	http://www.500px.com	http://www.500px.com
Behance	Share your portfolio.	Adobe (Behance)	http://www.behance.net	http://www.behance.net
EyeEm	Photo sharing and editing app.	EYE'EM	https://www.eyeem.com	https://www.eyeem.com
Facebook	Mobile app for sharing on Facebook.	Facebook, Inc.	https://www.eyeem.com	https://www.eyeem.com
Flickr	Mobile app for Flickr.	Yahoo	http://www.flickr.com	http://www.flickr.com
Google Photos	Photo sharing on all devices.	Google	http://www.google.com/photos/	http://www.google.com/photos/
IFTTT	Customizable channel sharing.	IFTTT	https://ifttt.com	https://ifttt.com
Instagram	Photo sharing and editing app.	Instagram, Inc	http://www.instagram.com	http://www.instagram.com
Oggl	Photo sharing and editing app. Shares Hipstamatic Lens and Film packs.	Hipstamatic, LLC	http://hipstamatic.com/oggl/	
Pinterest	Mobile app for Pinterest.	Pinterest, Inc.	https://www.pinterest.com	https://www.pinterest.com
Tumblr	Mobile app for Tumblr.	Tumblr	https://www.tumblr.com	https://www.tumblr.com
Twenty20	Mobile app for Twenty20.	Fast Labs Inc.	https://www.twenty20.com/signup/photographer	https://www.twenty20.com/signup/photographer

Community

APP NAME	DESCRIPTION	PUBLISHER	iOS	Android
AMPT Community	A global network of mobile photographers, artists & videographers.	Philip Parsons	http://amptcommunity.com	http://amptcommunity.com
Art of MOB	Interviews, tutorials, app reviews, giveaways, and amazing mobile images from around the globe.	Geri Centonze	http://artofmob.blogspot.com	http://artofmob.blogspot.com
iPhone Photography School	Tutorials. Interviews. Contests. News and updates.	Emil Pakarklis	http://iphonephotographyschool.com	http://iphonephotographyschool.com
iPhoneogrpahy Times	App reviews. Trends. Technology. Tutorials.	Jack Hollingsworth	http://paper.li/photojack/1318767396	http://paper.li/photojack/131876396
Life in Lofi iPhoneography	iPhoneography artist and app reviews.	Marty Yawnick	http://lifeinlofi.com	http://lifeinlofi.com
Skipology	"My world and me through iPhoneography". App reviews, genres, and techniques.	Paul Brown	http://skipology.com	http://skipology.com

Index

A

Adobe Lightroom, 162–163
Adobe Photoshop CC 2014
 content aware fill, 20
Alien Sky, 94
Apple QuickTake 10, 100
Application Programming
 Interface (API), 29
App-Stacking, 119
Auto-synchronization, 163

B

Best Camera App, 30

C

CAMERA+
 adjustable filters, 77–78
 Clarity Pro, 77
 features, 75, 77
 lightbox, 76
 separate+ focus and exposure
 reticles, 75
 shooting and non-destructive
 editing, 74
ClassicINSTA app, 39–40
Composition technique
 balance, 57–58
 color, 59–60
 curves, 56–57
 depth, 61–63
 framing, 65–66
 light, 60–61
 lines, 56–57
 negative space, 58–59
 rule of thirds, 55–56
 shapes, 56–57
 symmetry and pattern, 63–64
Creative iPhoneography
 composition (see Composition
 technique)
 EDITING (see EDITING Apps)
 Enlight's editing tools, 95–96
 master shot, 53–54
 special effects, 92–94

D

Digital darkroom
 at the computer store, 3
 dialog box, 4
 digital cameras, 9–10
 digital editing software, 11
 director, 6
 display, 4–5
 early software and hardware, 3
 first digital camera, 7–8
 gray scale images, 4
 Hypertext Markup Language, 6
 Kodak Photo CD system, 8–9
 MGM Grand and Silver Legacy, 6
 traditional agency approach, 6
Digital editing software, 15
Digital single lens reflex
 cameras (DSLR), 15
 creative revolution, 21
 Nikon D1 in 1999, 15–16

Digital single lens reflex
 cameras (DSLR) (*cont.*)
 post-processing and editing, 17
 seasoned photographers, 20
 tactile stimulation, 21
 workflow, 16
Directional inspiration, 110–111
Directional visualization
 experiment, 105–108

▓E

Editing Apps
 photos (iOS 9) (*see* iOS 9)
 snapseed, 87–90
 VSCO Cam, 91
EyeEm
 editing modules, 159
 photo sharing platform, 157

▓F

Facebook
 Flickr, 151
 mobile app, 153
 organize photos, 152
 pages and groups, 154
 personal and business
 accounts, 153
Filter Storm Pro, 43
Flickr
 DSLR photographers, 147
 licensing attributes, 147
 mobile app, 148
 one-touch filters, 149
 photo sharing service, 147
 special interest
 groups, 148
Fragment–Prismatic
 effects, 93–94

▓G

Google Photos, 161
Green visualization
 experiment, 101–104

▓H

Hipstamatic app, 45

▓I, J

iCloud, 160
Image blender
 loading, first image
 layer, 123–124
 loading, second image
 layer, 123, 125
 luminosity blend, 127
 switching, blend mode to
 luminosity, 126
Industrial Light and Magic (ILM), 5
Input devices, limitations, 17
Instagram
 behind the scenes, 146
 built-in social sharing, 144
 editing (advanced), 146
 filters, 144
 hashtags, 145
 photo-sharing, 144
 "post once—share many"
 concept, 146
 sharing, social media
 networks, 147
iOS 9
 additional settings, 70
 AE/AF Lock, 71–72
 CAMERA+, 74–78
 exposure slider, 71
 features, 68
 flash control, 73
 modes, 72
 optimal shooting, 69
 photos editor
 Color and B&W, 82
 external editor, 82, 85
 tapping Revert, 82, 87
 photos editor crest filter, 82, 86
 ProCAMERA, 78
 timer control, 73
 vividHDR, 79–81

iPhoneography
Avebury England, 38
ClassicINSTA app, 39
description, 37
High Dynamic Range apps, 37
Instagram, 36
iPhone, 35
new iOS app, 36

K, L

Keyboard, 17
Kodak/AP NC2000 digital camera, 10
Kodak Photo CD system, 8–9

M, N, O

Mextures, 50, 92–93
app-stacked image, 131
copper plated texture
application, 130
nebula texture
application, 129
Mouse, 18

P, Q

Photo sharing
art, 143
iPhoneography, 143
mobileography, 143
Pinterest
"nopin" meta tag, 159
"pins" on boards, 160
Pixlr-o-matic app, 38
Portrait editing
edited portrait photo, 119
lighting effect, 116
patch tool, 114
smooth tool, 115
teeth whitening, 113
wipe tool, 117
ProCAMERA, 28
vs. Camera+, 79
features, 78
500px, 150–151

R

Repix, 49
blurrer tool, 132
final edited image, 137
hatching tool, 134
spray brush application, 136
stark filter, 133
undoer brush application, 135

S

Shooting apps
camera (iOS 9) (see iOS 9)
JPEG format, 68
"lossy" format, 68
Silicon Beach Software, 4
Snapseed
blur effect
adjustment, 122–123
editing tools, 87–88
filter modules, 87, 89
HDR Scape filter, 120–121
noir filter activation, 121–122
non-destructive editing, 90
Software Development
Kits (SDKs), 28

T

Tilt Shift Generator App, 42
Touch experiments
facetune
blemishes, edit, 114
lighting effect, 116
portrait editing, 112–113,
115, 118–119
smooth tool, 115
teeth whitening, 113
wipe tool, 117
image blender
blend mode to
luminosity, 126
loading, first image layer, 124
loading, second image
layer, 125

Touch experiments (*cont.*)
 luminosity blend, 127
 steps, 123, 125
 mextures
 app-stacked image, 131
 copper plated texture
 application, 130
 nebula texture
 application, 129
 steps, 128, 131
 repix
 blurrer tool, 132
 final edited image, 137
 hatching tool, 133–134
 spray brush
 application, 135–136
 stark filter, 133
 undoer brush
 application, 134–135
 snapseed
 blur effect adjustment, 123
 HDR Scape filter, 121
 Noir filter activation, 122
 steps, 120, 122
Touch photography
 and iPhoneography, 40, 48
 app-stacking, 48
 Camera+ by Tap Tap Tap, 45
 description, 39, 46
 Filter Storm Pro, 43
 Gyan Mudra controls, 47
 HDR, 43
 the Hipstamatic app, 45
 iPhone and iPad devices, 44
 Mextures app, 50
 painters and artists
 experience, 47
 Repix app, 49

 shot with ClassicINSTA, 40
 Tilt Shift Generator App, 42
Touch technology
 Application Programming
 Interface, 29
 the App store, 28
 Best Camera App, 29–30
 digital photography, 23
 iOS developer, 28
 the iPhone at
 Macworld, 25–26
 iPhone 3GS, 26–27
 Motorola Razr V3xx, 25
 the Motorola V551, 23–24
 new workflow, 29
 Nikon D-50 DSLR, 24
 operating system, 27
 ProCamera App, 28
 technical computer user, 31
 VGA quality shot, 24
Tumblr
 HTML and CSS code, 149
 microblogging service, 149
 photo sharing, 150
Twitter
 Behance, 155–157
 followers, 154
 microblogging platform, 154

■ U

Universal Serial Bus (USB), 17

■ V, W, X, Y, Z

vividHDR
 features, 79
 "Lazy HDR", 79, 81
VSCO Cam, 91